EARLY MEDIEVAL ART
IN THE BRITISH MUSEUM

EARLY MEDIEVAL ART

IN THE BRITISH MUSEUM

By

ERNST KITZINGER

PUBLISHED BY
The Trustees of the British Museum

56-26837

PRINTED IN GREAT BRITAIN BY
CHARLES SKILTON LTD., LONDON

CONTENTS

v

CONTENTS

PREFACE TO THE SECOND EDITION

THIS edition is essentially a reprint of the 1940 edition, with only a few minor alterations. The reprinting was initiated by my predecessor, Mr. A. B. Tonnochy, F.S.A., in response to a steady demand from scholars, students and the public.

R. L. S. BRUCE-MITFORD

Keeper of British and Medieval Antiquities

The British Museum
March, 1955

PREFACE TO THE FIRST EDITION

THIS handbook has been written under my supervision by Dr. Ernst Kitzinger, of Munich, a German refugee scholar who for some years has been attached to the staff of this Department. As it was intended that the author should treat his subject as fully as the great resources of the British Museum allowed, we have disregarded Departmental boundaries and have made use of materials in the Department of Manuscripts and in the Department of Egyptian and Assyrian Antiquities. I have to thank the Keepers concerned, Dr. H. Idris Bell and Mr. Sidney Smith, for the generous help they have so willingly given us. The proof has been read by Mr. A. B. Tonnochy and Mr. William King, Assistant Keepers in this Department, and by Mr. Francis Wormald, Assistant Keeper in the Department of Manuscripts.

T. D. KENDRICK

The British Museum Keeper of British and Medieval Antiquities
January, 1940

Gold ornament with hunting scene, from Asia Minor
Fourth century ($\frac{4}{1}$.) (*See* p. 26)

I
LATE ANTIQUE AND EARLY
CHRISTIAN PERIODS

THE student of early medieval art is faced with the difficult task of naming a date at which the Middle Ages may be said to have begun. Some historians think that A.D. 313 is such a date, the year of the Edict of Milan, through which Christianity was, recognized as a state religion. Others hold that the abdication of the last Roman emperor in A.D. 476 marks the turning point between the classical and the medieval periods; while yet another alternative is provided by the founding of the first Germanic Empire under Charlemagne in A.D. 800.

In art history the last date is the one most frequently adopted. It is not usual to speak of medieval art before the time of the ascendancy of a Christian civilization in Northern Europe. The preceding centuries, known in art history as 'Late Antique' and 'Early Christian', were for a long time a kind of no-man's-land, rarely entered by the classical archæologist and even more seriously neglected by the medievalist. Art was thought to have come to an end under the later Roman emperors, and the five hundred years which elapsed between the age of Constantine and that of Charlemagne were regarded as devoid of any interest from the artistic point of view. What attention they did attract was warranted by theological rather than æsthetic considerations, this being the period when the first churches were built and the representations of Christ and His Saints and of many Christian figure-subjects took their shape.

But the researches of the last few decades have revealed more and more clearly the great positive importance of the art of these intermediate centuries. Far from being merely decadent

and dull, they are now known to have played a vital part in the evolution of medieval style. Their significance, indeed, is two-fold. First, they ensured the continuance of the classical tradition in art, which was in grave danger of dying out when pagan religion and pagan civilization died, and secondly, they provide the starting-point for that process of transformation by which the classical style of the Greeks and Romans was changed into the abstract and transcendental style of the Middle Ages. It may be surprising to be told that the classical tradition continued into medieval art; but we must realize that the very existence of representational art in the Middle Ages is an illustration of classical survival. At first Christianity was averse to any kind of imagery, which it rejected not only as a possible source of idolatry, but also as a symbol of worldly splendour and luxury. It was as a concession to paganism that Christianity admitted art into the Church, and consequently many details of antique iconography and style found their way into Christian art, which then survived into the Middle Ages. On the other hand, we do not always realize that what appears to us to distinguish medieval art fundamentally from classical art, namely its naïve and primitive and archaic character, is not, or at least not only, due to the influence of the barbarians of Northern Europe, but to a gradual transformation inherent in late classical art and making its appearance before pagan Roman art had come to an end. The Early Christian centuries thus occupy a key position between the classical and the medieval periods, and a survey, however brief, of the development during these centuries is necessary for the study of early medieval art.

It was during the third and fourth centuries A.D. that the Christians began to adapt classical art to their purposes. We have little evidence of what one may properly call artistic

activity among the Christian communities during the first two centuries of their existence. But the more followers they attracted in the large towns of the Græco-Roman world, the more difficult it became to maintain the austerity of the primitive Church. If the average pagan convert could not be expected to give up the pleasant and beautiful things with which he surrounded himself in his everyday life, still less could he be expected to exclude the arts from his religious observances. Accustomed as he was to an array of marble statuary representing the gods he worshipped, it was difficult to attract him to a religion which had to offer him no more tangible object of veneration than the written word.

Early Christian art betrays its origin in its entire character. The earliest Christian works of art were produced in a completely pagan environment. In the third and fourth centuries there were probably painters and sculptors who worked both for a Christian and a pagan clientele, and it is small wonder that Christian art borrowed from contemporary pagan art its style and sometimes even its subject-matter.

There are many instances of classical figure-subjects being taken over unchanged by Christian artists. We find representations of putti, Seasons, and other pagan allegorical subjects in the wall-decorations of the Roman catacombs which belong to those centuries. Tritons and Nereids are frequently represented on Christian sarcophagi. All these figures were regarded as not incompatible with the new religion. They were general symbols of the next world, of heaven, and of eternal happiness—all matters of no less importance to the Christians than to the heathen. A famous instance of pagan figure-subjects being taken over by the Christians without any change is the bridal casket of Projecta (Plate 10), a silver casket decorated partly with idyllic pictures of Venus, Tritons, Nereids, and putti, and partly with scenes of marriage ceremonies, while in

the accompanying inscription the bride and bridegroom are exhorted to lead a Christian life. In the East, pagan figure-subjects were even more persistently employed than in Rome. Egypt, for example, having been thoroughly imbued with Hellenic taste at the time of the Ptolemys, clung tenaciously to her pagan art, and far into the Christian period we find there garments and tapestries decorated with classical figure-subjects.

But such cases of actual copying, although the most obvious examples of pagan survival, are not, perhaps, those which had the greatest bearing on the further development of Christian art. As early as the third century attempts were made to give the traditional types a new and specifically Christian meaning. Thus we find pictures of Christ modelled on figures of Apollo, Helios, or some other youthful god or hero. No more suitable way could be found of expressing His divine mission than by giving Him features universally associated with the gods. Even more frequently was He represented as a shepherd with His flock. While this theme was, of course, inspired by the Gospel text, the composition is purely classical. During the fourth century these youthful and idyllic representations of Christ were gradually replaced by the more austere and majestic bearded type, but the inspiration again comes from pagan art, the models being older Olympian gods, such as Zeus or Asklepios, or portraits of great philosophers, who symbolized supreme wisdom. Angels were easily adapted from the Victories so frequent in Greek and Roman art. The insignia of imperial power and military triumph became symbols of the victorious Church. Characteristic examples of pagan iconography adapted to Christian ideas are provided by the gilded glasses which were found in great numbers in the Roman catacombs. For instance, the old Roman theme of a married couple united by Juno or a cupid is either taken over unaltered, or christianized by the simple but striking device of replacing the pagan deity by

a figure of Christ (Plate 5). The writers of Gospel manuscripts conformed to the pagan custom of inserting the author's portrait at the beginning of the book, in this case the evangelist, who is represented in exactly the same way as the classical writers and philosophers had been. This is the origin of the evangelist-portraits which play such a conspicuous part in medieval book-illumination (Plates 17, 18, 28, 36). Nor is the process of adaptation confined to figure-art. The Early Christian basilica has the form of the basilica of the Roman market-place adapted to the requirements of the Church service.

These few examples show that Early Christian art was developed from pagan prototypes. It may, indeed, be assumed that the Christians, having begun to use the arts for their own purposes, made a point of adapting well-known classical subjects so as to make the change in their inner meaning all the more apparent. But there were many themes for which no models were available, as, for instance, New Testament stories. These had to be conceived afresh, and it is in these free inventions that the full force of the classical tradition becomes apparent. There was certainly no prototype in pagan art for the Raising of Lazarus, but the painter naturally laid the scene in front of a classical tomb. The Entry into Jerusalem was modelled on an emperor's triumphal arrival at the gates of one of his cities.

Such instances can be easily multiplied. And with the classical iconography classical style naturally penetrated into Christian art. There is no stylistic difference between Christian paintings and sculptures of the third and fourth centuries and the contemporary pagan work. Catacomb paintings are executed in the familiar manner of the wall-decorations of Roman houses. The style in both cases is a debased version of the impressionistic manner evolved in the early days of the Roman Empire and seen to best advantage in the frescoes of Pompeii. The paintings

B

of the Early Christian period are all executed in this sketchy, versatile technique, which was capable of representing by means of light strokes of the brush a figure in lively action with a recognizable 'glance' in the eyes, and surrounded by a landscape full of light and air. About the year 400, when the earliest surviving manuscript illuminations were painted, this style was still alive, as is shown in the famous illustrations of scenes from the Bible in the Cotton Genesis (Plate 12). There is nothing peculiarly Christian about these miniatures, which have their closest parallels in contemporary illustrations of Virgil and Homer.

But neither pagan nor Christian works of art of that period lived up to the highest standards of classical art. The Græco-Roman style had completely degenerated by the time it was taken over by the Christians. Even the outstanding works of Early Christian times like Projecta's Casket cannot really be compared with the highest achievements of Roman art, to say nothing of the masterpieces of Hellenic times. In the best examples the figures recall the earlier work, but usually it is easy to recognize a certain stiffness and awkwardness in the attitudes, a lack of proportion in the bodies, and a want of expression in the faces. The artists imitate the traditional forms without entering into their spirit, and the beauty of the best classical art has disappeared altogether.

Yet these works can be described in other than purely negative terms, if judged by the standards, not of the classical age which lies behind them, but of the medieval period which comes after them and which they in fact foreshadow. The very features which from the classical point of view appear as short-comings acquire a new and positive value when seen in the light of the development which was to follow.

Thus even the earliest Christian works are not merely in-stances of the survival of classical features. They also serve to

illustrate that other aspect of our transition period which makes it important from the point of view of medieval art, namely the transformation of classical style into a transcendental, abstract style. To trace the origins of these abstract tendencies we must go back beyond even the beginnings of Christian art. They appear in Roman art as early as the second century, and their foundations lie in an even more remote past. While the Greeks achieved the ideal representation of the human body, and the Romans perfected individual portraiture, and made a great advance in the representation of landscape and three-dimensional space, there were at the same time other peoples with different tastes and different traditions who did not share the classical artist's interests in the realistic representation of the outside world. In the East, in Mesopotamia and Persia, the ancient heritage of a rigid and hieratic official art had never entirely died out. In the North East, beyond the shores of the Black Sea, there were the peoples of the Steppes, the most prominent among them being the Scythians, who had no monumental art at all, but only portable objects decorated with fantastic animal designs. This is also true of the barbaric tribes in the North and North West, of which the Celts with their richly decorated bronze objects are the best example.

These self-contained cultures, with artistic ideals differing widely from the classical, had little direct influence on the development of style in the Late Antique period. What is more important from our point of view is the existence of border regions between the classical world on the one hand and the oriental and barbaric countries on the other. Classical art was widespread like the empires with which it was associated. In Hellenistic times it was carried to all Mediterranean countries by Alexander the Great. Countries like Egypt were thoroughly hellenized at that time, and the classical influence was strongly felt as far away as India. The same thing happened in Roman

times, and the imperial legions carried Roman civilization, and with it classical art, to the Rhine, the Danube, the Thames, and all over North Africa and the Near East. Wherever it appeared Græco-Roman art was accepted as the standard, if only because it revealed to peoples to whom it was still unfamiliar the more congenial art of depicting lifelike human figures in stone, metal, or in paint. But classical models thus followed by artists with quite different traditions naturally took on a local colour; superficially the features of a figure are the same as in Rome or Greece, but we often feel that the free attitude, the lifelike and individualized expression of the face, the natural and easy relation between the figures, in short, all the essential qualities which the Greeks had discovered, are not quite faithfully reproduced. Thus we find in many of these border countries an art which is classical in origin and general conception, but not in spirit. Typical examples of such pseudo-classical art are provided by those countries in the Near East with a strong artistic tradition of their own but falling sooner or later under Greek or Roman domination, such as North Africa, the Nile Valley, Syria, Parthian and Sassanian Mesopotamia and Persia, while further north inner Asia Minor and the island of Cyprus provide examples of this art.

The style naturally varies with the local traditions. Plates 1 to 4 show typical examples of such 'sub-antique' art. In the mummy mask from Egypt (Plate 4), for instance, we see a particularly striking mixture of classical and unclassical features. The mummy itself is, indeed, entirely in the Egyptian tradition, but the mask with the face painted on it appears at first sight purely Roman. This mixture is usual in Egyptian mummies from about the time of the Roman occupation. In the present example, which dates from the second century A.D., we find a particularly realistic and individualized portrait-head with all its details modelled in the subtle pictorial technique of which

Hellenistic and Roman artists were masters. There is, however, even in the face, an unclassical element, although it is psychological rather than stylistic. With its fixed gaze it seems to look beyond the spectator into infinity. The whole life of the portrait is concentrated in those eyes, which completely upset the harmony of the different parts of the face essential to truly classical portraiture. It is in this over-emphasis of a spiritual element having nothing to do with the characterization of an individual personality, that the Egyptian portraitist differs from his Roman contemporary. Two hundred years later artists in Rome also made such 'portraits' which show that the artist and sitter are conscious of an impersonal transcendental power more important than the particular features of the individual figure.

The bust from Palmyra (Plate 1) shows 'sub-antique' art diverging from classical standards in a different way. The artist obviously follows the model of official Roman art; for instance the draping of the toga and the fashioning of the beard are in the well-known manner of Roman portraits. But all the details are interpreted in a purely ornamental manner; the curls of the hair are treated as conventional spirals, and look as though they were made of some crisp pastry-like material; the eyebrows are almost like a palmette ornament, and the sharp and elegantly curved lines of the eyelids remind one of a piece of ornamental metal work rather than a living person. The bust betrays that conventional approach to the human form which the Greeks, supreme masters in the rendering of organic and active life, had overcome, and which begins to reassert itself in the oriental hinterland of Syria as early as the second century A.D.

It is more difficult to recognize the ultimately classical roots in a work like the slab on Plate 2, which comes from the neighbourhood of Carthage and represents the provincial art of the North African coast. Were it not for the two figures in the upper corners, which are derived from the well-known

Roman representations of Castor and Pollux leading their horses, one would perhaps regard this relief as an entirely exotic work. The carving is flat, the figures all face the spectator squarely, their proportions are clumsy, their features grotesquely simplified. The folds of their garments have become completely stylized with ornamental forms. Particularly important from the point of view of the later development is the schematic order in the composition, the division of the panel in zones with a vertical axis dividing it in half. In its coarse and primitive way the relief anticipates that complete negation of the principles of classical art which the early Middle Ages were gradually to exemplify. At first sight this slab might appear to be an advanced product of the Dark Ages, but actually it is an extreme example of provincial Roman art, the work of indigenous North African sculptors who represented in this style the deities and symbols of their local cult.

Plate 3 is a specimen of the style of another regional school, which flourished in the Mediterranean area by the side of the official Græco-Roman art; it is a Jewish stone cist or ossuary from Palestine dating from about the first century A.D. It is covered with patterns partly derived from Hellenistic acanthus ornament, partly of oriental origin; in his treatment of the motives the artist reveals an unclassical taste characteristic of many of the border regions of the classical world. The ornament is achieved by means of sharp V-shaped cuts, so that we see fully lit parts alternating with deep shadows. The space is thus completely filled by a pattern in black and white, of which the background is no less important than the motives themselves. The intrinsic decorative value of the individual motive is, as it were, subordinated to this coloristic effect. If we think for a moment of a typical Greek or Roman ornament, for example a foliate scroll on a plain ground and depending for its effect entirely on the beauty of its own design, we realize

how different the principle is here. We shall see that this un-classical ornament, which aims at effects not dependent upon the actual shape of the motives, became extremely important in later developments.

Common to all the different examples of 'sub-antique' art is the attempt to superimpose some abstract principle on the natural forms of Græco-Roman art. In various ways, differing from one region to another, the border countries of the Roman world opposed deliberate stylization to the realism of classical art.

All these 'sub-antique' traditions would not, perhaps, have been of such importance had they been confined to the outer regions of the classical world. The decisive factor was the increasingly strong influence which these provincial styles began to exert on the art of the great capital cities, to some extent even as early as the second century, but much more definitely during the third and fourth. This is a development which points to great changes in the artistic ideals of those great centres. In fact, it has often been said that the internal changes which then took place in Rome and the other great towns are far more important than any influences that may have come from outside, and that the evolution of Late Antique art is largely the result of a complete transformation in the Roman Empire at that time.

It is, however, impossible to disregard the obvious links connecting the Late Antique style with the 'sub-antique' art of the previous centuries, the influence of which undoubtedly helped to shape late Roman art. On the other hand, it would be hard to maintain that this provincial style was imposed upon the metropolitan cities against their will and intentions. The change is certainly not due to provincial artists forcing their way into the big cities. On the contary, the abstract style was readily adopted, and, since in the course of the third and fourth

centuries it begins to appear on the most important official monuments of the Empire, it was clearly no longer regarded as provincial and inferior or connected only with the lower strata of the population, but was spontaneously recognized as the official art of Rome. This, however, points to profound changes in Roman life and taste, involving the abandonment of everything that classical art had achieved since the period of archaic Greek sculpture. It marks the end of a striving for almost a thousand years' duration after a 'humanized' art, an ideal in the attainment of which the Mediterranean civilizations had outshone all their oriental predecessors.

The most obvious explanation of this important change is to ascribe it to a general decline in artistic skill, due to the increasingly unstable political and economic conditions in the decadent Roman Empire. According to this theory the growing resemblance between official Roman art and provincial art shows that official art now became itself provincial. If artists are no longer trained to paint or carve a lifelike human figure, to study the characteristics of an individual face, or to create the illusion of a three-dimensional space in painting or relief, they will inevitably be reduced to those flat abstract compositions and stiff, rigid, impersonal figures, which the less pretentious works in the provinces had shown all along.

There is undoubtedly some truth in this contention. The average work of art of late Roman times betrays considerable carelessness; decline of technique and craftsmanship results in simplification carried to the length of crudity. But at the same time it is quite clear that there were artists who found new possibilities and positive merits in this 'provincial' style. If classical ideals were abandoned, it was not only because artists were no longer able to follow them, but also because they lost interest in them. They began to pursue new objectives for which 'subantique' art offered more adequate forms of expression.

A work like Projecta's Casket (Plate 10), with its strongly classical character, is, perhaps, not the best example of these new and positive tendencies in late Roman art. They are much more clearly visible in the ivory panel with the Apotheosis of an Emperor on Plate 6, probably also a Roman work of the late fourth century. Both in style and in spirit this carving marks the dawn of the Middle Ages in the late pagan art of Rome.

There are medieval elements even in its subject-matter. In the lower half of the panel we see an emperor, whose identity has never been finally established, seated on a chariot which is drawn by four elephants. In the upper half the same personage is being carried up to heaven (represented by signs of the Zodiac, the Sun-god, and a number of busts of uncertain meaning) by two naked and winged genii. In the centre there is a veiled pyre, from which a naked deity in a quadriga rises up to heaven, with two eagles flying upwards. All the details of this panel have not yet been adequately explained, but its general content is clearly an elaborate representation of the emperor's progress to the next world. It illustrates the belief in a life after death which, although in existence throughout the classical period, had never taken such definite shape and had never been made the subject of so much interest and speculation as in this late period. Neo-Platonic and Mithraic beliefs, which dominated philosophy and religion in late Roman times, were entirely centred in the hereafter, and the panel illustrates that interest in the supernatural and transcendental, which had then taken possession of the classical world and is one of the signs heralding the end of classical antiquity.

The style of this carving, although at first sight purely decadent, also contains novel elements. There is a complete and significant neglect of the third dimension. The figures, although meant to be at varying distances from the spectator, all appear in one plane. An attempt has been made to render

the canopy surrounding the figure of the emperor in perspective, but the illusion of depth is destroyed by the representation of the elephants' feet and the wheel of the car all on one level in the foreground. Equally significant is the loss of individual characteristics in the faces, the rigid staring eyes, and the clumsy, awkward attitudes of the figures. All these features are familiar in 'sub-antique' art. If they now begin to occur on monuments which obviously bear an official character it is not, or not only, because they required less skill. There is a positive intention behind them.

For example, the absence of perspective and the simplified composition and figure-design is a better indication of the subject. The artist's main interest is his story, he is anxious to convey a definite message, and he invites us to concentrate on this rather than on details of form. In classical works of art we always find a perfect balance between content and form. The loss of this balance marks a new stage in art-history, a stage in which art becomes a vehicle for the propagation of certain doctrines.

Yet it would be wrong to say that our artist simply neglects formal values. There is in this carving an almost deliberate protest against realism. The sculptor makes it clear that he has no confidence in formal beauty and naturalism. He disregards the laws of nature; he shows that he is not interested in such things as three-dimensional space and the anatomy of the human body. For these he substitutes other values. His concern is the abstract relationship between things rather than the things themselves. Instead of a realistic scene, he shows us a solemn assemblage of persons with the emperor as the central power. A composition thus arranged like a geometrical pattern on a single plane with a blank background of indefinite depth is removed from the sphere of actual life and has a spiritual meaning, a symbolic and transcendental character.

There are, therefore, new and positive qualities in this mis-named decadence, which are closely bound up with those moral and religious changes which the subject-matter of our panel reflects. It was the tendency of the age to seek an escape from the material world, and men found refuge and consolation in the spiritual.

But the scene is not merely a statement of such values. Perhaps its most significant aspect is its strong and direct appeal to the spectator. A classical work of art is entirely self-contained; figures on a Greek relief turn to each other unaware of our presence and independent of it. This scene, however, is presented to us ceremonially: all the principal figures are conscious of our presence. The whole composition is spread before us, and is meaningless without the spectator. Thus not only the outlook of the artist has changed but also his function. He makes a direct appeal to his public, he has a definite message to convey and he also aims at a definite pyschological effect, as the solemn and awe-inspiring figures on our ivory clearly show. An entirely new art is here in the making, different from classical art both in its approach to the outside world and in its relation to the spectator. The style of 'sub-antique' art was adopted because it offered more adequate expression for these new aims. It was made to serve a new purpose.

The full result of this revolutionary tendency was not to become apparent until much later. The art of the high Middle Ages is its final outcome. It was left to the painters and sculptors of the twelfth and thirteenth centuries to discover the final and perfect form for the spiritual and the transcendental. It was the medieval Church that brought to perfection the use of art as a didactic instrument and as a vehicle for the propagation of the Faith. The rigid solemnity to which our sculptor aspired finally materialized in the figures of Christ in Majesty enthroned over the porches of the medieval cathedrals. The

motionless impersonal faces arrayed monotonously in the upper zone of our carving have their successors in the rows of saints of medieval paintings and reliefs.

Roman art of the third and fourth centuries initiated this movement, and therein lies its greatest significance. It should be noted that the decisive turn took place at a time when there was still very little Christian art. Classical art became 'medieval' before it became Christian. The new creed is not a primary cause of the change. The art which the Christians took over from their pagan contemporaries was already on its way towards the Middle Ages.

Having thus indicated, however briefly, the twofold origin of Early Christian art, we must now describe its development from the fourth to the eighth century. But since not only Early Christian, but all medieval art is derived from two sources, the classical and the non-classical, a few general observations may be made bearing on our whole subject. Throughout the early medieval period there is a struggle between the two elements, and not until its end is harmony reached. Most of the works illustrated bear the marks of conflict and uncertainty, a fact which sometimes makes the approach to them a little difficult. Again and again one feels tempted to judge them by classical standards. And yet, if such standards are applied, it is only too easy to discover all sorts of mistakes and misunderstandings. It must always be borne in mind that the medieval artist, even when he appears to be imbued with classical taste, has little direct contact with nature. If he clings to classical traditions it means that he copies works of the classical period, or follows the technical processes of his forefathers. It does not mean that he studies nature as they did. The world of nature has little intrinsic interest for him. To that extent the break which came about in the Late Antique period is decisive and final.

Classical tradition in early medieval art mostly means that types created by Greek and Roman artists are taken over as convenient and ready-made formulae. The copying of models plays an important part throughout the medieval period. This second-hand classicism is very often the most prominent feature of early medieval art, and yet it is hardly ever a clue to its real importance.

On the other hand, the development in the direction of a truly abstract art is far from uniformly progressive, and this, again, is a fact which makes the art-history of the early Middle Ages difficult to understand. Our bust from Palmyra (Plate 1), dating from the second century A.D., anticipates statues on Romanesque cathedrals in an astonishing way. A figure in a Byzantine miniature of the tenth century, however, reproduces classical models so faithfully (Plate 36) that it is difficult to believe that almost a thousand years separate it from the period of Pompeian wall-painting. Thus the pendulum swings constantly between the two extremes of a homely and naturalistic, and a geometrical didactic art. The two tendencies exist together, and it is not always easy to recognize the gradual progress, which is, nevertheless, made towards the final goal.

In the present chapter we have to deal with the first stage only of this evolution. This, however, must be described separately for different parts of the Mediterranean world. The Roman Empire had fallen to pieces, and during the Early Christian centuries national units emerged, whose individual character finds an expression in their artistic styles. In the struggle between classical and anti-classical tendencies the various regions of the ancient world play widely different parts.

In a brief survey like this it may suffice to distinguish between three main areas: the Latin, the Greek, and the Oriental.

In the Latin area Italy was still the focus of cultural life,

although Spain and Southern France also took part in the development. It would be wrong to assume that after the transfer of the imperial residence to Constantinople early in the fourth century the influence of Italy at once disappeared. The first real shock came with the barbaric invasions of the fifth century, which not only hindered cultural activities in Italy but also led to her becoming, at least for a time, more and more dependent on the protection of Constantinople. By the sixth century Italy was, in fact, hardly more than a province of the Eastern Empire. But the quest for national independence led to a steadily widening cleavage between Rome and the East during the following two centuries, and to the gradual assertion of a national style in art.

Italy had been chiefly responsible for the adoption of those abstract principles which, as we have seen, were a death-blow to truly classical art. It has often been said that the Roman artists developed this style not independently but under strong oriental influence. Others have contended that Italy had never really been a home of classical art in the same sense as Greece, and that the return to abstract art was facilitated by the 'Italic spirit' inherited from Etruscan and Republican times, and only temporarily overshadowed by the philhellenic leanings of the ruling class of Rome during the first two centuries of the imperial era. The most important reason, however, is the fact that Rome was still the centre of the world at the time when those decisive changes in the intellectual outlook described above took place. It is owing to this fact that Italy shows the gradual absorption of 'sub-antique' elements in the official art of the Empire more clearly than any other region. By the time Christianity attained official recognition, in A.D. 313, the most representative monuments in Rome were treated in a frankly abstract and 'primitive' style, as, for example, the reliefs made immediately after that date for the Arch of Constantine. With

their two-dimensional compositions, their monotonous rows of block-like figures, whose attitude is determined by spiritual rather than by naturalistic principles, and with the symmetrical arrangement and hieratic qualities of at least some of their scenes, they are an even more striking instance of 'medievalism' in Italian fourth-century art than our ivory panel.

During the subsequent periods these characteristics assert themselves again and again. Rigid symmetry, flat composition without perspective, and clear linear design may be described as typically Latin characteristics. But the development is far from straightforward. There are frequent returns to a more classical manner, for the Hellenistic tradition in Italy was strong and powerful. Moreover the country was continuously subjected to the influence of other styles from the East, especially in the centuries of political dependence. It, therefore, offers very typical examples of that continuous struggle between classical and anti-classical tendencies, which is an outstanding feature of the history of early medieval art.

Not all the stages of this development can be traced here. But attention must be drawn to the first important revival of the classical spirit which took place towards the end of the fourth century, after the abstract and 'transcendental' vogue of the Constantinian age. Even under Constantine the classical tradition had probably not entirely died out, but it came more to the fore in the second half of the century. This has its parallel in general history in figures like Julian the Apostate. There was in Rome still a powerful minority of pagan aristocratic families who now made a point of displaying an artistic taste founded on the masterpieces of the classical period. It is likely that this 'renaissance' movement started in these pagan circles, but as even conservative aristocrats gradually adopted Christianity, their traditional taste became at that time typical of pagans and Christians alike. No object illustrates this point so clearly as

Projecta's Casket. Projecta married a member of a family prominent in the group of pagan aristocrats, and although she and her husband were Christians, the style of her bridal casket bears the marks of the strong pagan traditions in the family.

Even when commissioning a painting or a sculpture, which in its subject-matter was to give definite proof of their new religion, these aristocratic patrons insisted on the classical standards of form being maintained. A large group of works was executed in Rome about A.D. 400 which, although Christian in content, is nevertheless classical in style. Thus it happened that, for a short time at least, classical beauty and refinement were introduced into Christian art.

This fact had a profound and permanent influence on the subject-matter of Christian art. Hitherto it had been largely symbolical. Even biblical scenes had only been represented for the sake of their symbolic value. The Sacrifice of Isaac, Daniel in the Lions' Den, Noah in the Ark, Jonah and the Whale, the Raising of Lazarus, were little more than symbols of resurrection and salvation. True to his calling as a 'preacher', the artist confined himself to some principal features which served to impress on the spectator the moral of the story. Old and New Testament scenes were often mixed because the essential meaning was the same in both. Now we begin to find narrative cycles either of the Old or the New Testament illustrating in a series of scenes a number of consecutive episodes with a great amount of realistic and even anecdotic detail. The interest in lives of biblical persons and events begins to replace purely theological interest. It is hardly an accident that this return to the descriptive manner of the historical reliefs of the Romans coincided with the introduction of a more classical style in Christian art.

These historical cycles taken from the Bible were to be perpetuated in a steady and continuous tradition throughout

the Middle Ages. The British Museum is fortunate in possessing the earliest extant cycle of scenes from the Passion executed in this narrative manner. Earlier representations of these scenes had been less detailed, and the Crucifixion scene had never been represented realistically but had only been suggested by means of a cross guarded by two soldiers. The panels from an ivory casket on Plate 7 show all the scenes enriched not only by a great deal of narrative detail, such as the sack with the thirty pieces of silver cast away by Judas, but also by what must be one of the earliest representations of the crucified Christ.

These panels also illustrate, to some extent, the classical revival in style. The soft and fleshy character of the bodies with their gently rounded outlines and delicately modelled draperies, the illusion of depth in the scene of the 'Denial', the languid attitude of some of the figures, for example the guardian to the right of the Tomb; all these features combine to give the reliefs a more classical appearance than that found on the Emperor's Apotheosis. They are, however, by no means the most typical specimens of this classical interlude, and in many respects they exemplify the opposite tendencies. Some of the figures are treated as statuesque figures rather than as living persons; for instance, on the Crucifixion panel no attempt is made to represent Christ or Judas really as hanging bodies. Some of the other figures are also unduly clumsy, both in attitude and proportions, and one at least of the scenes shows a marked tendency towards a symmetrical composition spread out in front of a plain background.

The 'renaissance' was, indeed, short-lived. In the course of the fifth century the abstract elements again predominated in Western art, and in many ways our panels foreshadow the linear and architectural tendencies which Italy was henceforth to represent in the general evolution of early medieval style. Although again and again new factors appeared, largely as a

C

result of Byzantine influence, it was this abstract, geometrical style which finally prevailed in Italian art.[1]

From the Western Mediterranean countries we turn to the East where we may first consider the coast regions as opposed to the Asiatic and African hinterland. All along the shores of Asia Minor, Syria and Egypt, the Greeks had established a firm hold at the time of their political hegemony. Some of their towns, such as Ephesus, had at an early date become great centres of commerce and industry as well as of religious, intellectual and artistic life. More large cities had grown up in those regions under the successors of Alexander the Great, cities which surpassed the capital in splendour and importance, and preserved their metropolitan character, even after they had fallen under Roman rule. Antioch and Alexandria are the most famous.

These centres had played a leading part in the later stages of the evolution of Greek art. Greek taste and Greek style had taken root there, and when, in the third and fourth centuries, classical style began to degenerate, the artists in the Eastern Mediterranean towns did not carry the new abstract and primitive tendencies to quite the same length as their Roman contemporaries. In a sense, indeed, the Mediterranean world was a unit, and in that critical period classical ideals were abandoned in the East no less than in the West. Moreover, the Roman rulers exerted a standardizing influence, and official work instigated by the imperial administration shows the new abstract tendencies wherever it appears. In fact, those Eastern towns were, perhaps, instrumental in adapting the 'sub-antique' art of their hinterland to the purposes of official imperial art,

[1]Unfortunately, the Museum does not possess examples of Late Antique art in Italy after the fifth century.

and works like the porphyry sculptures, which were commissioned by the Roman rulers but mostly made in Egypt, are among the first to show unequivocally the new abstract, hieratic style.

In the unofficial art of Alexandria, however, and the other large cities, the lively and colourful manner of Hellenistic art still persisted in the fourth century. We find it in the decoration of mosaic pavements, in ivory and bone carvings, which served as an ornament for many objects of daily use, in metal work and textiles. That this style also survived in the Christian art of the East is shown by works like the Cotton Genesis (Plate 12) and the ivory diptych leaf with the figure of an Archangel (Plate 8).

The Cotton Genesis, the earliest illustrated biblical manuscript known in the Greek world, is almost universally regarded as the work of an Alexandrian painter of the early fifth century. Unfortunately, all that has survived of the rich cycle of illustrations once contained in this manuscript is a series of half-burnt fragments. But some of these clearly show the sketchy impressionistic manner of classical painting. We find figures with faces indicated by only a few black strokes, lively expressive movements, backgrounds of light and transparent colours which give an illusion of depth and atmosphere, while buildings in perspective and figures standing half hidden behind those in the foreground also help to create an impression of depth. It is true that these artists, no less than their counterparts in the West, had lost direct contact with nature. Many figures are much too large in proportion to the buildings surrounding them, and for the sake of simplification figures are often shown facing, and the outlines of houses made to coincide with the frame. But as an heir to the true Hellenistic tradition the artist still tried to give a realistic and vivid illustration of his story and,

unlike his Western contemporaries, he refrains from changing his figures into masses conceived sculpturally, and does not try to convert a free and casually grouped scene into a rigid architectural composition. A comparison of the Crucifixion panels and the Cotton Genesis illustrates these diverging tendencies. The contrast between East and West is not yet so clear at the time of the Western 'renaissance', about A.D. 400, which, it may be noted, was perhaps under strong influence from the Hellenistic centres in the East. But it becomes more and more marked in the course of the fifth century. The Archangel relief, which is hardly earlier than sixth century, shows that, even at that time, Greek artists still endeavoured to give their Christian figures the appearance of Greek statues. Here, again, forms are not correct in the classical sense. The angel's feet rest on a flight of steps behind an arcade, while his hands and his two wings seem to suggest that he is standing in front of that arcade. But the carefully modelled body, the delicately carved drapery, and the calm detached expression of the angel's face suggest that, although no longer interested in realistic details, the artist, nevertheless, is anxious to capture the surface effect of a classical relief.

The Hellenistic tradition in the Eastern Mediterranean countries is a vitally important factor in the general evolution. It has often been said that it is not a feature of those regions in general, but more especially of Alexandria which alone is supposed to have continued to act as a focus of Hellenistic civilization and style into late Roman and Byzantine times. But as yet we are not really able to distinguish between the Late Antique styles of towns like Alexandria, Antioch and Ephesus, and as they all had a strong Hellenistic tradition, it is advisable to attribute the style to the Eastern Mediterranean coast in general. Moreover, there is definite evidence to show that by the fifth century every one of these towns had lost at least some of its importance. At that

time the centre of gravity in the Eastern world had already shifted to the new capital on the Bosphorus, and we have reason to believe that there, in the neighbourhood of the imperial court, were the workshops which continued to minister to the most refined Hellenistic taste amidst the ruins of the classical world. Constantinople attracted the best artists from the neighbouring shore, and, by the sixth century, when under the Emperor Justinian the Byzantine Empire reached the height of its power and expansion, the town was adorned with buildings of unexampled splendour. No other town had anything to compare with his greatest architectural triumph, the Hagia Sophia. At that time Constantinople had undoubtedly become the leading city in the East, and the provincial centres began in their turn to depend on the influence of the capital. A figure like our Archangel may therefore be described as typically Byzantine work, either from Constantinople itself or from a provincial school which worked in the refined and aristocratic, if somewhat staid and academic, manner favoured in the metropolis.

A group of works in which the classical leanings of the court are particularly pronounced are the Byzantine silver vessels. Many of these bear imperial control-marks which show that they were made, if not in the capital itself, at any rate under the supervision of the government. They are often decorated with embossed reliefs, and even as late as the seventh century the subjects of these reliefs are often chosen from classical mythology. They are executed with so full a knowledge of classical style that they were thought for a long time to belong to the second or third century. Plate 11 shows a silver vessel from Cyprus which, although Christian in subject-matter, is still to some extent classical in appearance. The stamps on this vessel are probably those of the Emperor Phokas (602–610).

But the Eastern Mediterranean coast was not only a great

centre of Hellenic culture, it was also very close to regions in which 'sub-antique' art had flourished in Roman times, and thus we find side by side with forms which bear witness to the survival of a comparatively pure classical tradition many stylistic features which belong to the anti-classical current in Late Antique art.

The charming gold plaque opposite page 1, for instance, shows as a background to a hunting scene an openwork pattern which owes its effect, not to any definite ornamental motives, but to the glittering interplay of light and shade. The figures, instead of being firmly supported by a solid background, as is the custom in classical art, float in an indefinite space. A 'sub-antique' technique of ornamentation is used to achieve an effect of vagueness and transparency, an effect in which Byzantine artists delighted, and which became an outstanding feature of many of their buildings, mosaics, and reliefs.

A similar combination of classical figures with unclassical ornament is seen in the fragments of a Byzantine illuminated Gospel of the seventh century (Plate 13). Here the arcades surrounding the Eusebian canon-tables are covered with motives quite unknown in classical art, while the little medallions between the arches contain busts of saints in the best impressionist tradition of Hellenistic painting. The ornament is unclassical, not only because it consists of rows of disconnected flowers and leaves, a feature unknown to Greeks and Romans and very common in the 'sub-antique' art of the Syrian hinterland and Sassanian Persia, but also on account of its strange relationship to the architectural framework. Architecture and ornament have exchanged functions. The latter, instead of being subordinated to the columns and arches, is the predominant feature, and the architecture is reduced to a system of faint outlines which look like the conventional frame of a purely abstract pattern.

This unclassical influence is not confined to ornament. It is also very conspicuous in certain figure-compositions and explains the long rows of saints standing stiffly facing the spectator on a background of gold, with large black eyes and a gloomy air, and also the figures of emperors in heavily jewelled garments seated solemnly on thrones, hieratic and somewhat barren representations which we are accustomed to regard as the most typical products of Byzantine art. We know this art, for instance, from some of the mosaics of Ravenna. Dating from Justinian's time, when the town served as the residence of the Byzantine exarch in Italy, they appear to reflect not unfaithfully Byzantine works of that time, and although contemporary mosaics and paintings have not survived in the Eastern capital, it is, for instance, hardly conceivable that the famous mosaics in S. Vitale, showing Justinian and Theodora in solemn procession, differed greatly from pictures of similar subjects in churches in Constantinople. We also know this solemn hieratic style from some of the Eastern ivory carvings of the sixth century, especially from the so-called consular diptychs, and the same tendencies manifest themselves in the ivory plaque with the Adoration of the Magi in the British Museum (Plate 9). This scene, which is usually represented in a lively natural manner, with the Magi approaching from one side and the Virgin seated in profile on the other, is here turned into a statuesque group. The figures are distributed symmetrically on either side of the Virgin, who sits facing, in an austere attitude, and whose eyes, large and staring like those on the contemporary mosaics, are firmly fixed on the spectator. A charming episode from Christ's childhood has been turned into a severe and awe-inspiring ceremonial.

Works like this illustrate the other side of Byzantine art. From its oriental hinterland Constantinople borrowed the elements of hieratic figure style and of a rich and gorgeous, but

rigid and abstract ornamentation. This aspect of Byzantine art is perhaps more familiar than the classical one, but it is important to note that the two styles existed side by side. Abstract art never succeeded in getting rid of the Greek tradition.

Like the Greek style it also occurs in other places on the Eastern Mediterranean coast, and it is possible that its grip on some of these provincial centres was even stronger than on the capital. Thus it is chiefly in Palestinian monuments that narrative subjects like the Adoration of the Magi are turned into hieratic images, and it may well be that our ivory panel comes from the Holy Land rather than from the Bosphorus. But it is, nevertheless, a typically Byzantine work. The artist was familiar, not only with the hieratic but also with the Hellenistic style, for beneath the solemn Adoration scene he represented the Nativity in a much less stiff and more classical manner.

Nothing could show more clearly the duality of styles prevailing in these regions. Situated on the border-line between two worlds, the Greek and the Oriental, Byzantium evolved two entirely different modes of expression. It delighted in reminiscences of the lifelike, free and delicate art of the Greeks, and at the same time it adopted the cold splendour and gloomy austerity of Asiatic art, appropriate to an age of strict political and cultural organization and intellectual and religious coercion.

Finally, we cast a brief glance on the third region that played an important part in those early centuries, namely, the Orient proper. The works of art comprised under this heading do not all come from one country, nor are they all uniform in style. There were behind the coastal belt of the Eastern Mediterranean a number of provinces which developed an artistic style of their own in early Byzantine times. Inner Asia Minor had its own art, differing from that of the Aegean shores, while Syria and Palestine had their very distinct local peculiarities, and a particularly

striking example of a distinctive regional style is provided by the Early Christian works of art in the Nile Valley. At a greater distance from the Mediterranean are Mesopotamia and Armenia, both with a highly developed art of their own. The characteristics of these individual styles stand out most clearly in a survey of their architecture. But they also produced paintings, sculpture and minor objects with a very striking local flavour.

Typical examples of such provincial art of early Byzantine times are the illuminated manuscripts of inner Asia Minor (especially Cappadocia) and Syria. Manuscript illumination in these countries was largely in the hands of monasteries, which were centres of learning and hotbeds of theological controversy. To the monk subject-matter was the main interest and book-illustration was applied chiefly for the purpose of making the text more intelligible and the argument more convincing. Everything not essential for elucidating the point of a story was omitted. There are no pictures of the type of those in the Cotton Genesis, with their classical apparatus of scenery and frame. The figures are painted directly on the background. In many cases they do not even have a compartment to themselves, but appear on the margin of the text as a kind of pictorial commentary. Their style is derived from classical models, but the painters, not being bound by court etiquette like their colleagues in Byzantium, and less afraid of innovations, do not hesitate to vary the appearance of a personage according to his function in the scene, and to sacrifice correctness of design to vigour of gesture and action. The charm of these figures lies in the poignant expressiveness of their eyes and hands. Some of them are not executed in colours, but are merely outline drawings, and the pen brings out their expressive character even more strongly than the brush. The British Museum does not possess any examples of Early Christian book-illumination from

Cappadocia or Syria. But the tradition survived into later centuries, when it was practised even by certain monastic workshops of the capital, and to gain a general impression of this lively narrative art it is permissible to refer to the miniature from a Byzantine Psalter of the eleventh century on Plate 35, an illustration which belongs to a later section of our text.

While painters in Asia Minor and Syria thus developed the element of graphic expressiveness contained in the Hellenistic style of Byzantium, Palestine, as has already been mentioned, favoured the hieratic style. Flasks (*ampullae*) containing sacred oil and water, reliquaries and other objects connected with the cult of holy places are frequently decorated with scenes from the life of Christ, characterized by strict symmetry and stiff monumental figures. It has been observed above that this manner was not confined to Palestine alone, but it appears to have been particularly in favour there.

The most distinctive local art, with a style clearly distinguishable from that of all other regions, grew up in Egypt. The Nile Valley, although nominally under Byzantine domination, stretched too far south into the African continent to be effectively administered by the central government. The Egyptians had their own form of Christianity, and their continuous struggles with the official Church led in the fifth century to the establishment of an independent national Church which is known as Coptic, a term that also describes the Christian art of Egypt.

The peculiarities of this art had begun to develop even in pagan times. Egypt had been thoroughly Hellenized when it was under Greek domination. Hellenistic art had become the property of all; the houses were full of terra-cotta statuettes in Greek style, textiles were decorated with putti and other gay and colourful designs of classical origin, and buildings were

adorned with foliate friezes and mythological reliefs. As the people's art this decorative style survived side by side with the official work carried out on behalf of the Roman, and afterwards Byzantine, rulers. As long as Alexandria continued to play its part as a guardian of genuine Greek culture and art, this Hellenistic style was maintained on a fairly high level, notwithstanding the unclassical and 'sub-antique' elements which we found in mummy portraits and other products of popular art at an early date. As the influence of Alexandria gradually weakened, this provincialized version of Hellenistic art came more and more into its own.

It is on account of its origin in the everyday art of Græco-Roman Egypt that Coptic art is so largely decorative. Even in Christian times the Eygptians did not cease to decorate their churches with foliate designs, animals and geometrical patterns, and as late as the eighth century we still find garments adorned in gay colours with naked putti and other pagan motives, despite the numerous protests of the clerics against this particular form of heathen survival. Naturally, Christian figure-subjects were also introduced in paintings, sculptures, and textiles, but even they are often made to serve a largely decorative purpose.

Coptic art, therefore, is much less an instrument of instruction and propaganda than the Christian art of Italy and Byzantium. With its mainly decorative character and its lack of literary content it curiously foreshadows Islamic art, which was to achieve some of its greatest triumphs on Egyptian soil.

The stylistic development consists in a gradual elimination of classical and naturalistic forms. Abstract regularity, symmetry, repetition, a preference for the full-face view of the human figure, features which had been characteristic of the 'sub-antique' art of the provinces, now help to transform the Hellenistic heritage, and the process was further intensified

through influence from the hinterland of the adjoining Asiatic countries.

Our tombstone (Plate 15), which dates from the seventh century, shows Coptic decorative art in its highly conventionalized stage. In the foliate scroll, and even in the bird, one may still recognise classical tradition. But all organic forms are completely subordinated to an ornamental composition, and the abundant use made of the contrast of light and shadow results in a carpet-like all-over pattern covering the whole slab, in which individual motives of the decoration take a subordinate place. Similar tendencies were seen in the 'sub-antique' art of Jewish Palestine many centuries earlier. Thus we see how in the hinterland regions of the Byzantine Empire Hellenistic art was gradually adapted to a taste rooted in old local traditions.

The increasing subordination of organic forms to a decorative design is particularly clear in the textiles which the desert soil of Egypt has preserved in great numbers. Up to the sixth century the Hellenistic element is still very noticeable, and we find artists endeavouring to make us forget the regularity of the texture by skilfully weaving a naturalistic figure-design into the system of wefts and warps. But our silk panel of about A.D. 600 (Plate 14) shows how the shapes of men and animals are gradually adapted to the straight lines and right angles of the texture. All the outlines are made angular and the details of faces and garments are simplified accordingly. Moreover, the weaver had made use of the mechanical repetition which the loom made possible, and thus we find our horseman and his dog faced by their exact counterparts rather in an armorial fashion. Even biblical scenes are often treated in this manner on Coptic textiles, and thus it becomes quite clear that they are regarded as an heraldic pattern rather than as an illustration of a story. In the case of these textiles it is perhaps Persian

influence that has helped to bring about this complete trans-
formation of the classical models.

These few examples must suffice to characterize the various
regional schools which developed in the oriental hinterland of
Byzantium. We are confronted with a great variety of different
styles, but, nevertheless, there is some justification for including
them all under one heading. They are all in a similar relation-
ship to Byzantium. We have said before that Byzantine art
penetrated into the provinces, and in some of the regions named
we find monuments which might have been made in the capital
so little do they differ from the work of Constantinople. As
opposed to this international element the works which we have
now discussed represent the local and indigenous styles of the
various provinces. Naturally there is not always a clear division
between the international and the national style of any parti-
cular region, for Byzantine productions were often imitated by
the local craftsmen. But on the whole we may say that the
regional elements belong to the hinterland as opposed to the
coast, that they represent the art of the people as opposed to
that of the court, and where cultural activities were largely in
the hands of monasteries, as in Asia Minor, Syria and Egypt,
the local art is often linked up with this particular type of
community.

Another point common to these local styles is the æsthetic
attitude of the artists towards the international art of late
antique and early Byzantine times. The regions in which they
developed are largely those in which 'sub-antique' art had
flourished in the first centuries after Christ. The artists in these
areas now take up the same attitude towards Mediterranean and
especially Byzantine art as their forefathers had adopted
towards classical art. The majority of types and motives, both
figure-subjects and conventional ornament, are derived from
Mediterranean art. The provincial craftsmen imitate it and at

the same time interpret it in their own peculiar way. They over-emphasize some particular element and concentrate on a particular point such as decorative design or expressive human gestures. The models are simplified, and features of local origin are added. The results, however much they differ among themselves, are always marked by an increase in stylization and abstractness. At the same time the provincial styles reflect in a general way the development in the Byzantine sphere. And in their turn they exert influence not only on Byzantine but also on Western art.

Even this brief survey has shown how many different styles developed side by side in the Late Antique and Early Christian period, and in how many different ways the various parts of the Roman Empire reacted to the breaking-up of classical art. In the heart of the Empire is Byzantium, which remains closest to the classical tradition and becomes its most faithful guardian. But both in the East and in the West the opposing tendencies gained more and more ground, and developed in various different ways. And even Byzantine art did not remain uninfluenced; it adopted many elements of abstract art, especially from its Eastern neighbours.

During the seventh and eighth centuries the period of the absolute predominance of the Mediterranean countries, united by their classical heritage and to some extent by the Byzantine rule common to them, gradually came to an end. In Byzantium itself there was, soon after the glorious reign of Justinian, a marked decline both in the number and in the quality of artistic productions. At first it seems to have been a mere pause after the immense efforts of the preceding decades, but soon political and economic difficulties appeared, which were to prove serious obstacles in the path of artistic evolution for many centuries to come. First there were, late in the sixth and early in the seventh century, the Persian invasions which resulted in

the temporary loss of Syria, Palestine and Egypt. Then, in the course of the seventh century an even more powerful enemy appeared in the East, namely Islam. In less than a hundred years most of the Asiatic provinces of Byzantium, as well as the whole North African coast and even Spain, were absorbed by a new and entirely different civilization. The crisis in the Mediterranean world was aggravated by the fact that the antagonism of East and West, represented by the Emperor and the Pope respectively, assumed more violent forms than ever. This fact has a particular bearing on art-history, since the struggle took the form of a quarrel over the admissibility of pictures in Christian worship, known as the iconoclastic controversy.

The result of these various events was that Byzantium, although still the largest and richest town of the world ceased to be its unchallenged centre. The Byzantine Empire was henceforth but one power among others on a much reduced territory. And from the point of view of art it lost, at least temporarily, an even greater part of its importance, since it became, for more than a century, the champion of iconoclasm.

The eighth century, therefore, is a critical period in Mediterranean art-history. At the same time a new star arose north of the Alps, namely the Frankish kingdom, raised to the status of an empire by Charlemagne, its greatest ruler.

Thus began the second phase in the evolution of medieval art, in which the North took the lead.

II

CAROLINGIAN ART

WHEN Charlemagne embarked on his ambitious scheme, which aimed at a revival of the Roman Empire and Roman civilization under Frankish leadership, there was in the countries north of the Alps an artistic tradition of long standing, largely the heritage of the Migration Period (about 400–600). This Northern art was opposed to Mediterranean art in almost every respect. Associated in its origins with wandering and warlike tribes without fixed abode, it was almost entirely confined to portable objects, such as personal ornaments, weapons, and implements of daily use. It did not include immovable objects such as stone buildings, fresco paintings, mosaics and monumental sculptures. Goldsmiths' work, enamelling, the casting of small bronze objects, and bone carving were the crafts in which the Northern artists excelled, and their aim was not the representation of some definite subject, religious, historical or otherwise, but abstract ornament. Whether for those people the ornament on a weapon or a necklace still retained the magic power which had been the main reason for its original creation in primitive cultures, or whether it must be regarded as the outcome of a highly developed æsthetic sense, is a somewhat doubtful point. But in any case the barbarians of the North held aloof from the materialistic representation which had been brought to perfection by the Greeks and Romans and had been inherited by the Christians in the Mediterranean countries. While in Italy and Byzantium sumptuous churches were built and decorated with mosaics and figure reliefs, and manuscripts were illustrated with figures and historical scenes, the Northern artists

were absorbed in the invention of rich and increasingly fan-
tastic ornaments with which to cover their brooches and pins,
their belt-clasps, drinking horns and sword-hilts. Some of these
ornaments were purely geometrical and showed such designs as
spirals, zigzag and step patterns. But they also used animal
figures for the purpose of decorative design and even the por-
trait-busts and horsemen on Roman coins. They transformed
these realistic motives almost beyond recognition, treating
them exactly like abstract patterns, first splitting them up and
then mixing their details in a most illogical manner. Animals of
fantastic shape were juxtaposed in rows, and their limbs were
interlaced so as to form hybrid and intricate all-over patterns.

With the spread of Christianity in the seventh century the
first contacts with the Christian art of the Mediterranean were
established. In Merovingian France, in Ireland, and in England
churches began to be built in stone in the Southern manner.
Large-scale sculpture in stone was introduced and widely applied
in the high crosses which abound in Ireland and Northumbria.
Most important among the new crafts introduced by the
missionaries was the writing and illuminating of books. The
Gospels were the motive power behind the Christian mission
and elaborate pictorial illustration their almost indispensable
accessory. Under the patronage of the Church all the principal
Mediterranean crafts were thus established in the North, but
they had only a limited influence in matters of style. The native
tradition not only remained unimpaired in the secular field,
but it became the principal source of inspiration even for the
decoration of churches, sculptures and manuscripts. It is true
that at a very early date efforts were made by the Christian
artists in the North to emulate Mediterranean models. The
earliest crosses of Northumbria, for instance, show classical
types of figures and ornaments handled with astonishing skill.
But the barbaric spirit soon gained the upper hand again, and

D

with even greater speed it appropriated the illumination of manuscripts as its own province.

The miniatures of the famous Gospel manuscript written in Lindisfarne about A.D. 700 (Plate 16) illustrate this point well. Fantastic animals intricately interlaced, abstract knot-patterns, spiral, fret and step ornaments, in short the whole stock of barbaric designs, has been poured out over these pages as a decoration of the sacred text. There are in this and many other Irish and Northumbrian manuscripts pages covered entirely with ornament, a thing unheard of in the book-illumination of the South, where miniaturists never used orna-ment except to mark the beginning or the end of a chapter, or to frame an illustration. A leaf bearing nothing but ornament would have appeared meaningless to them. In the North, however, a page need not necessarily contain writing, or an illustration pertaining to the text, in order to justify its presence. A manuscript is an object suitable for pure decoration, like a knife or a brooch. Ornament represents everything that is rich and splendid and beautiful, and where the artist associates it with holy scripture it is his own way of paying a tribute to the glory of God.

These ornamental pages are, of course, extreme cases of bar-baric taste trespassing on Christian ground. Definite attempts were made to introduce the figure-subjects of Southern book-illumination. But it is nevertheless astonishing to see the com-plete independence with which the Northern artists approached their models and the markedly abstract effect they achieved even when representing human figures. The evangelist-portraits in the Lindisfarne Gospels (Plate 17) show no back-ground of scenery. There is no indication of the place where the holy man sits. No effort is made to make us forget the neutral bleakness of the page. The only piece of furniture, the stool, has been turned into a curious pattern of ornamental

ribbons hardly solid enough to support its occupant. In fact, all parts of the picture, the human figure and the bird no less than the chair, are treated as one big ornament. Nothing is more telling in this connection than the way in which the inscriptions are placed; they too are a part of the pattern, counterbalancing the eagle above the saint's head, and together with him they form a display of perfect, if asymmetric, harmony. The empty ground is used to set off this pattern, and the effect is that of an openwork ornament on a metal foil.

Being based on models of an entirely different character these portraits are the best witnesses to the artists' unfailing taste for ornamental design. With his frankly abstract and unnaturalistic approach to his subject, the Northern painter succeeds almost at the first attempt in creating that true image of a saint, wholly superhuman, wholly imperturbable, at which artists of the South had aimed for so many centuries.

These pre-Carolingian works of the North are, in fact, the perfect embodiment of the ideal of abstract art, the absolute antithesis to naturalistic representation. Compared with them Mediterranean art of the Early Christian period, whether on the classical or anti-classical side, is realistic and descriptive. Relatively the closest comparisons in the Mediterranean region are afforded by those oriental countries which also favoured a largely ornamental art, and it is curious to observe that when, in the seventh and eighth centuries, contacts with the South were established, Coptic and Syrian works often had greater attraction for the Northern craftsman than the more classical art of Byzantium. There is an inner affinity between a Northumbrian page completely covered with its carpet-like pattern (Plate 16) and a Coptic tombstone (Plate 15), and there is, moreover, in many works, especially of Irish and Merovingian art, a demonstrable oriental influence. The Christian civilization of Ireland, England, and France was in those centuries largely monastic,

like that of Egypt and Syria, and the monks and hermits in the
extreme North and West of Europe naturally maintained closer
contacts with their brothers in the East than with the more
cosmopolitan civilization of Byzantium.

It is of great historical importance that the Northern peoples,
to whom purely abstract art was a natural form of æsthetic
expression, then began to take a leading part in the European
development. But their influence on the further evolution of
Christian art did not at once become apparent. The continuity
of artistic production in the North was suddenly interrupted
by the Carolingian Renaissance.

Barbaric art was abstract to a degree that very nearly pre-
cluded its use by the Roman Church. It was inarticulate. It was
not suitable as an instrument of instruction or propaganda,
being incapable of conveying to the spectator a definite
message. As an illustration of historical matter this style was
entirely inadequate. This is undoubtedly one of the principal
reasons for the much more complete submission to Mediter-
ranean models which Charlemagne initiated. It was its wide
range of subject-matter, and the graphic and lifelike manner in
which this was represented, that made Southern art so attrac-
tive to that great organizer of Germanic civilization. We must
be careful not to look upon Charlemagne's renaissance move-
ment as though it were merely a matter of æsthetics, a question
of replacing the harsh and heavy barbaric manner by a much
softer and more elegant style. The main point was that by
faithfully imitating Byzantine or Italian manuscript-illlustra-
tions, paintings, mosaics and sculptures, the Northern artists
were suddenly enabled to depict the stories of the sacred books,
the subjects treated in the works of classical and contemporary
· authors, the personal appearance of the Emperor and other
leading figures of their time, and to do so in such a manner as
to make these subjects really live before the spectator's eyes.

It was a discovery of reality. As in many other periods of art-history this reality was not revealed by the direct copying of nature, but by recourse to the works of art of a preceding period.

It was not, indeed, Charlemagne's object to make artists appreciate and reproduce the outside world for its own sake. In fact, he and his contemporaries condemned art as a means of reproducing things which are obvious to the senses. They believed, however, in its usefulness in conjuring up the things of the past, and making them live. Charlemagne had a very clear vision of the part that such realistic art could play in his work of political and cultural reconstruction. If art succeeded in giving physical reality to things which otherwise could only be grasped intellectually it could be turned into a powerful instrument of education. This is the real reason why he turned away from the abstract ornamental art of the North and began to emulate Mediterranean models.

Undoubtedly an additional stimulus lay in the fact that these models still bore the stamp of the classical age, and recalled the great Empire which Charlemagne had set out to revive. But such an aim in itself would hardly have produced more than a dry and sterile classicism, which would have died with the political power through which it had come into being. As it was, Northern art was put on an entirely new basis, which was to determine its character for ever after, and far from confining itself to purely formal imitation of Roman or Byzantine work it soon produced masterpieces like the Utrecht Psalter and the Crystal of Lothar (Plate 25), whose figure-subjects, clearly based on Mediterranean models, are rendered with such a lively sense of movement and drama, of vivid gesture and realistic expression, that the artist must be credited with having excelled his Mediterranean forerunners in their own sphere. The classical forms in these cases are hardly more

than the raw material beaten into a new shape by artists with a fresh and unblunted power of observation. Charlemagne did not merely aim at a superficial imitation of classical imagery; he imbued artists with a desire for lifelike and graphic representation, and turning to this task with a fresh and eager eye, they often achieved a degree of perfection which few of their more or less decadent models can have possessed.

Art thus became a means of instruction and enlightenment, part of the programme of education through which the great ruler intended to raise his people from barbaric obscurity to European leadership. In the churches and monasteries, which were the centres of all his educational work, he possessed an instrument for organising this artistic revival systematically. The clearness of purpose and the methodical and comprehensive way of putting it into practice is not the least important feature that distinguishes the Carolingian Renaissance from the previous approaches of the North to Mediterranean art.

The great monasteries as well as the imperial palace had workshops attached to them. The most important centres were those situated near the heart of the Empire on the Lower Rhine and in Northern France; for instance, Trèves, Aix-la-Chapelle, Rheims, Metz and the monastery of St. Martin of Tours, but great artistic activity was also displayed in the more outlying regions, as, for instance, in Salzburg and the Bavarian monasteries and at St. Gall in Switzerland.

When one looks at a group of Carolingian works such as is reproduced on Plates 18–25, the great difference from the barbaric work of the preceding period is at once apparent. There is a much wider range of subject-matter. New Testament iconography is no longer confined to solemn images of Christ and the evangelists. Scenes from the Saviour's life, His childhood, miracles and Passion are depicted in elaborate

narrative cycles, and Old Testament stories are also frequently illustrated. Equally striking is the difference in style. Figures are plastic in appearance, they are often caught in three-quarter view and move about naturally and with great liveliness. Their gestures are expressive and convincing, their garments are softly modelled and the folds are rendered with truth to nature. We seem to be carried back to the art of the Cotton Genesis and the Projecta Casket.

But at the same time it is obvious that with their comprehensive submission to Mediterranean art Charlemagne and his followers also took over the stylistic discrepancies inherent in it. The Southern works which served as models must have differed much among themselves. To understand this it must be remembered that out of the common classical traditions various and strongly diverging styles had developed in the different Mediterranean countries during the Early Christian period. Charlemagne recruited artists from all these countries, who naturally brought with them their native styles. An even greater variety of influences came from the many objects of art which were procured from various sources, in order to serve as models in the Carolingian workshops. Gradually by copying from the same models again and again local stylistic traditions were built up in the individual Carolingian schools, and these styles never ceased to reflect the different foreign sources from which they were derived. In the styles of rival schools the conflicts inherent in Late Antique and Early Christian art were thus perpetuated in the Carolingian period.

Among the various groups in Mediterranean art which influenced the Carolingian schools there was first of all the lively impressionistic style of Hellenistic times which, as we saw, had continued to flourish in Byzantium and other centres on the Eastern shores. There is a group of book-illuminations

painted at the time of Charlemagne himself and traditionally known as the 'Palace Group', which are genuinely Byzantine. One of them actually bears the signature of a Greek artist, and there can be little doubt that direct influence from the Eastern Empire is responsible for their style. At the time of Charlemagne's immediate successors in the second quarter of the ninth century we find the miniaturists of Rheims following the model of this group, and in their hands the sketchy impressionistic manner of the Greek prototypes finds its most faithful reproduction, as may be seen in the illustrations of the Utrecht Psalter. At least an approximate idea of this most famous of all Carolingian manuscripts may be formed from the Harley manuscript 603 (Plate 29A), which is a copy of the Utrecht original made in England about the year 1000. The painters of Rheims in their turn handed on the tradition to a school of ivory-carvers whose home has never been finally determined, a school which copied the miniatures of the Utrecht Psalter, and imitated their style as closely as the different medium would allow. The ivory on Plate 24 belongs to this class known by the conventional name of 'Liuthard Group'. There is reason to believe that the Liuthard ivories are the work of a generation following that of the artists of the Utrecht Psalter, so that in the sequence represented by Palace miniatures, Rheims miniatures, and Liuthard ivories, we perceive the survival of the Hellenistic style of Byzantium throughout the three consecutive generations during which Carolingian art chiefly flourished.

Side by side with this Greek school another group of artists had begun to evolve a style of an entirely different character. Their works, known as the Ada manuscripts and Ada ivories, are thought to have been created under the immediate influence of the court. But whether they were actually executed at Aix-la-Chapelle, or at Trèves, or some other place on the Lower

Rhine, has never been decided. This school follows Mediterranean models entirely different from those used by the artists of the Palace group and their successors. All figures, especially in the earliest manuscripts, are drawn with heavy outlines. They are not by any means as lively as those of the rival school, and instead of being surrounded by open landscape and atmospheric space they are fitted into a heavy architectural framework. Owing to the absence of impressionistic technique and of modelling by light and shade the figures are apt to be flat and somewhat rigid. It is on account of their greater solemnity that they seem to be a likely product of a representative court art. The source of this style has often been thought to be the oriental hieratic style which we have found was practised in Byzantium and other Eastern centres side by side with the Hellenistic narrative manner, but the closest parallels to these stiff and solemn figures with their regular features, their wide open eyes, their heavy outlines, are in contemporary wall-paintings in Italy, where one also finds the background acting as a solid framework to the figure and holding it in a firm and immovable position. Italian artists had by that time brought to perfection the architectural style which they had favoured since the Late Antique period. They had consistently transformed classical figure-compositions by introducing architectural principles such as symmetry and frontality, by ruling out all suggestions of real life and subordinating everything to a strict system of horizontal and vertical lines. This style is clearly reflected in the earliest works of the Ada school, which thus represents the abstract, geometrical, Western Mediterranean element within Carolingian art as opposed to the descriptive and narrative Eastern Mediterranean style of the Palace, Rheims, and Liuthard groups.

But as the Ada school developed, other, and secondary, influences began to modify its style. Figures became more lively

and realistic; their bodies were given a more plastic character; the folds of their garments acquired a more natural and softer shape, and the backgrounds, although still strictly architectural, became more spacious. It is to this period that the Ada manuscript and the Ada ivory in the British Museum belong (Plates 18, 19, 22). They still show the characteristic linear style of this group, but a definite influence of more classical models can also be observed. Compared with works of the Palace and Rheims group the evangelist in the miniature still seems flat and constrained. He is surrounded by a strongly conventionalized architectural frame and everything in the picture is drawn with heavy outlines. The elaborate distinctness of all forms, which is a leading characteristic of the Ada style, is equally obvious in the ivory panel, especially when compared with its companion from the Liuthard group (Plate 24). But both in the painting and in the ivory carving the original stiffness of the Ada style shows signs of relaxing.

The niche in which the evangelist sits is fairly spacious. He is seen in a natural attitude, and the rich folds of his garments are modelled in a subtle manner, with soft dark strokes and thin flickering lights. When we compare this page with a miniature from Byzantium (although in this case a later one: Plate 36) it becomes apparent that the softening of all forms is due to influence from that quarter. It was in Byzantine painting that the impressionistic modelling of figures and draperies, the perspective drawing of architecture, and the technique of subtle light and shade had survived. The Carolingian painter absorbed these forms without, however, abandoning the essentially linear and architectural character which the Ada school favoured. Byzantine influence is noticeable in many of the later works of that school, not only in its miniatures, but also in some of the large ivory book-covers of which it produced a great number.

It was not only through the Byzantine models that the artists of the Ada school became familiar with a more classical and natural rendering of figures and scenery than the original style of the school had enabled them to give. In their search for classical models they found that the Latin West also possessed such works, although not contemporary. They were attracted by the ivory carvings produced in Italy at the time of the revival of an aristocratic classical style in the late fourth and early fifth centuries, and with that scrupulous and almost pedantic accuracy which is characteristic of the Ada group they began to copy those works of a distant past. Our ivory panel (Plate 22) is a typical specimen of this kind of work within the Ada school. It is copied from a Western Early Christian work rather in the manner of the Passion panels (Plate 7). There we find the sturdy thickset figures filling practically the whole panel from top to bottom; the round faces with their bulging eyes and protruding lips; and the fat rounded limbs which are discernible even through the folds of a garment.

The Ada group has a great number of works testifying to this archaistic spirit. But the same spirit also affects other groups, for instance, the manuscript-illuminations localized at Tours. Plate 20 shows two Old Testament scenes (Moses receiving the Law and Moses speaking to the Israelites) from a large Bible manuscript written at Tours about A.D. 840. The figure-types, the architecture and landscape scenery, the costumes, and even the colours are all so true to the style of Late Antique art that the miniature can be claimed with much probability to be based on the model of a Roman painting of the fifth century. Of all the Carolingian works here illustrated this is perhaps the one which most faithfully reproduces a work of an earlier age. It shows the Northern artist, only recently initiated into the secrets of descriptive imagery, sitting at the feet of the classical masters. When we try to fit together the heads, bodies and feet of the

figures in the lower part of the page we very quickly realize that this is not the work of an artist to whom the sympathetic rendering of an historical event was a natural preoccupation.

These few examples may suffice to show how varied were the influences which helped to create Carolingian art. Early Christian no less than contemporary works from Italy and Byzantium contributed towards its making. Yet, as long as we confine ourselves to revealing its foreign sources we do not do full justice to Carolingian art. Equally important, although not always so easily discernible, is the contribution of the Northern artists themselves. Many painters and sculptors soon tired of mere copying, and began, sometimes perhaps quite unintentionally, to interpret their models in their own way. But there too different schools display different tastes.

Emphasis has already been laid on the extreme liveliness which the artists of the Rheims and Liuthard schools knew how to impart to their figure-subjects. In this respect they surpassed whatever Southern models they may have had. None of the Byzantine miniatures of the kind related to the illustrations of the Utrecht Psalter possesses quite the same expressiveness in movement and gesture, and the Liuthard ivories, which show this lively and versatile style translated into a new medium, have an even stronger claim to originality. The closest parallels in the Mediterranean sphere to those delicate and agile little figures, with their quick movements and emphatic gestures, are in the Asiatic hinterland (Plate 35; see above, page 29) and it may well be that influences from that sphere contributed to the making of this style. But a work like the Utrecht Psalter or our Liuthard plaque is not all second-hand. Although the scenery, the types, and the costumes are according to convention, the figures have had a new soul, a new life, and a new vitality infused into them. The story has acquired for the artist a degree of reality which made pure copying impossible. In his

own mind he re-enacts the Bible stories, and before him arises a fresh and dramatic vision of figures and scenes. There are hardly movements and gestures strong enough to express the emotional content he discovers in them. Suddenly enabled to use art as a means of depicting definite subjects he is seized by an elemental desire to make it speak and give visual form to spiritual and emotional themes.

The supreme example of the rejuvenation of Southern narrative style in Carolingian art is the Crystal of Lothar (Plate 25). It is not known where this masterpiece was made, but the artist must have been at any rate acquainted with the work of the Rheims school, especially the Utrecht Psalter, and the lively little figures enacting here with a wealth of vigorous gesture the story of Susanna and the Elders are of a vivacity all the more impressive in that it is in striking contrast to the icy and intractable nature of the rock-crystal on which they have been carved. In a work like this we see the birth of a new kind of beauty which medieval art with its bold disregard for classical harmony, correctness, and restraint, and its passionate interest in moral and transcendental subjects possesses exclusively.

The special contribution of the Northern artists in these examples originates in their very readiness to accept the aims and standards of an illustrative and expressive art. Other schools, however, reveal a survival of the essentially ornamental interest which had dominated pre-Carolingian art in the North. There was, in fact, a school of book-illumination in North-Eastern France which confined itself almost entirely to the imitation of the Irish and Northumbrian styles of the eighth century. This is the so-called Franco-Saxon school, of which only a comparatively modest example can be shown here, perhaps not even a product of the main school itself, since this group had far-flung ramifications in Belgium and North

Germany (Plate 21). It shows the rich decorative framework of the insular manuscripts with their characteristic corner-pieces and the huge initial letters with their fantastic interlaced and animal designs which entirely dominate the page. The only Carolingian influence in the miniatures of this group is an occasional acanthus border or a small figure of an evangelist inserted in the framework.

The Franco-Saxon school was of great importance in the dissemination of insular ornament in Carolingian and post-Carolingian art. But the same ornamental spirit pervades in a more subtle and less easily perceptible way other Carolingian schools. The artists of the Ada group, for instance, take a special delight in elaborating details in an ornamental manner. The draperies on our ivory panel (Plate 22) are certainly copied from Late Antique models, but these can hardly have shown a display of folds as rich as that of the Angel Gabriel in the Annunciation scene, where the ruffled borders of the coat have almost acquired the character of an ornament independent of the general composition of the figures. The interest in rich ornamental design is even more pronounced in the manuscripts of the Ada school. The artist who painted the figures of the evangelists in our Harley manuscript (Plate 18) was clearly more concerned with the zigzags and triangles of the draperies and their undulating borders than with the structure of the body underneath, and the elaborate architectural background, which is much richer than in Southern manuscripts, also adds to the ornamental effect of the page. Thus it is not surprising to find in several of the Ada manuscripts pages which are entirely made up of ornamental motives, including the interlacing and the fantastic animals of Irish and Northumbrian art. Although many classical details, such as foliate capitals, acanthus friezes and other leaf patterns have been added, these are in essence decorative pages comparable to those in the insular manuscripts. Plate 19

shows such a page from our Ada manuscript; the small scene inside the letter Q is of secondary importance.

It is an extremely significant fact that the repertory of abstract ornament, especially the richly decorated initial letters and other ornamental features of barbaric manuscript illumination, were taken over by the Carolingian artists and amalgamated with classical motives. The belief in ornament for ornament's sake, so conspicuous in the pre-Carolingian art of the North, is thus perpetuated even after the standards of descriptive Mediterranean art have been definitely adopted. The artist who delights in pure form and follows in his work nothing but his own imagination does not disappear altogether with the Carolingian Renaissance. He adds Mediterranean foliage ornament and even figures to his fantastic animal and knot patterns. But the spirit remains the same, and from the Carolingian schools the heritage is passed on to the mature art of the Middle Ages.

The Carolingian Renaissance, therefore, does not altogether imply a submission to Mediterranean art. In two different and even contradictory ways the North makes its own contribution to the art of the period. On the one hand the new search for naturalism leads to an expressiveness unknown even in the best of the Mediterranean models. On the other hand, the conception of traditional abstract art has not disappeared. These two conflicting tendencies represent a dilemma, which the Carolingian period does not attempt to solve. There is no unity of purpose among the artists. Works like the Ada miniature (Plate 18) and the Lothar Crystal (Plate 25) were created side by side.

This conflict, however, is not entirely new, but perpetuates, though in a fresh form, the struggle that we have already studied in the Mediterranean world. It is hardly a coincidence that the artists who excel in expressiveness are those whose style shows Byzantine influence, for instance, the painters of the

Rheims school, nor can it be pure chance that ornament plays but a modest part in this school and remains confined to an imitation of classical motives. The abstract and linear style of the Western models used by the Ada school, however, lent itself at once to an ornamental interpretation, and to these figures, already strongly stylized and geometrical in design, purely ornamental motives were easily added. The conflicting Northern contributions were, therefore, associated with different Mediterranean models, or, in other words, were merely interpretations of the conflicting Mediterranean styles. The old contrast between Greek realistic and Latin abstract art, between art aiming at a sympathetic representation of the outside world, and art based on purely conceptual design, presents itself in a new form as a contrast between the exuberant expression of human emotion and the purely impersonal ornamental display.

From the point of view of Greek art both these tendencies are, of course, unclassical. Both show how far the distance from truly classical art had increased since the Northern peoples had taken the lead. The leanings towards expressive and communicative art involve a typically medieval emphasis on subject-matter and emotional content at the expense of material form, while the ornamental spirit tends to rule out imitative forms altogether. But within this medieval sphere 'expressionism' always ensures a certain amount of realism and a frequent return to classical models with their rich stock of figure types and other formulae necessary to convey some particular message, whereas the ornamental tendency is always simply and uncompromisingly abstract.

The contrast between the two currents is, however, not always so clearly demonstrable as in the comparison of the Lothar Crystal with the Ada miniature. Especially in the latter phases of Carolingian art in the second half of the ninth century

the styles of different schools tended to become confused, when artists often copied from the works of their immediate predecessors instead of going back to Mediterranean sources. Anxious to produce increasingly splendid and lavish effects, painters did not hesitate to copy a figure composition from the Rheims or Tours school and to surround it with an ornamental frame more in the manner of the Ada or Franco-Saxon schools. A group of manuscripts, variously localized in Corbie or St. Denis, is particularly rich in such hybrid and eclectic works. The general tendency is towards ornamental rather than expressionistic effects. The vitality of the period to which the Utrecht Psalter and the Lothar Crystal belong is gone. This late phase is illustrated by our ivory panel of the school of Metz (Plate 23). Although the models from which these reliefs are derived must have been at least related to the Liuthard group, there is nothing left of the vivacity of those earlier works. The relief is much flatter and there have disappeared both the deep shadows and the glaring high lights, which on the Liuthard ivories throw all the principal movements and gestures of a figure into bold relief. The outlines are much more definite, and at the same time the figures have lost their agility. They are plumper and much more stolid. Faces no longer reflect emotions, but tend to be of uniform schematic design. Details like eyes and mouths are no longer indicated in the sketchy technique of the Liuthard masters, and a particularly characteristic feature is the stereotyped manner of indicating the hair, which covers the head like a cap and is separated from the face by a neat, sharp stroke. The figures seem to have contracted themselves into a block; they are harder and colder, and, although they can still gesticulate expressively, there is no real communication between them.

But for all their symptoms of degeneracy these ivories are still typical examples of the Carolingian style. They illustrate

E

the survival of this art well into the tenth century. In the early years of that century the Frankish Empire collapsed but the innumerable works of art created under the auspices of Charlemagne and his successors continued to be used as models in all the countries to which their influence had spread.

TENTH AND ELEVENTH CENTURIES

WHILE Carolingian art thus assumed the leading rôle in Europe, Byzantium, although no longer the main force in the evolution of Christian art, continued to be a powerful factor in the background.

There was now a wide gulf between East and West. In the course of the iconoclastic controversy the Latin Church had separated itself completely from the Greek, and Italy had made herself politically independent of the East Roman Empire. The Byzantine sphere of interest was more and more confined to the Orient and the Balkan and Slav countries. In the artistic field Byzantium remained faithful to its old traditions and had no share in the new departure that the Germanic peoples had made in Western Europe. It is precisely this conservative attitude that constitutes its importance in the general evolution.

Throughout the Early Christian centuries Byzantium had remained the guardian of classical art. Even in the crisis of iconoclasm there had not been a complete break with tradition. Although hardly any monuments of the period have survived, we know that painting and sculpture, as well as the industrial arts, were practised to some extent even during the eighth and early ninth centuries. There was no objection to the representation of secular subjects or to purely decorative art. Even the prohibition of religious imagery was not enforced with equal rigour in all parts of the Byzantine Empire.

For indirect evidence of Byzantine style of the late eighth and early ninth centuries we have the Carolingian works which were inspired by Greek artists, for instance, the works of the

Palace and Rheims groups and also the later products of the Ada school. These show that even at that period Byzantine craftsmen had considerable knowledge of organic figure design and had mastered the technique of impressionistic representation. They knew how to represent figures in a natural attitude and showed skill in painting a face or garment in an impressionistic manner.

But direct evidence of artistic activity in Byzantium in this period is very meagre. It is not until the end of the ninth century, when with the establishment of the Macedonian Dynasty prosperity returned, political power began to increase and all kinds of cultural activities were revived, that the monuments become more numerous again. Some of the Macedonian emperors were not only great patrons of learning and literature, but they also restored buildings and decorated them with splendid mosaics. The minor arts, such as manuscript-illumination, enamelling and ivory carving, were also revived on a large scale. The tenth century is a period of great achievement in all these branches of art, comparable only to the time of Justinian, and usually called the second Golden Age of Byzantine art.

Plates 32–36 show typical works of that period. In all of them a strong classical element is apparent. We may note, for instance, the figures on the Nativity relief (Plate 33): Mary reclining comfortably on a couch, the midwife kneeling down to bathe the Child in an attitude both natural and perfectly balanced, and the Child Himself, doll-like and clumsy, it is true, but carved with a knowledge of the treatment of the nude which only an unbroken tradition of classical craftsmanship could have supplied. These Byzantine reliefs show neither that minute elaboration of detail, which reveals the ivories of the Ada group as works of imitators only recently initiated into the art of organic figure-design, nor that over-emphasis of expression and

dramatic effect by which the carvers of the Liuthard ivories betray their fundamentally unclassical character. Byzantine figures always show a greater poise and easiness in their attitudes. A comparison of the seated Joseph on the Ada relief and on the Byzantine panel demonstrates that in Byzantium classical art was a living tradition and not a laboriously conceived innovation.

The Macedonian period is often called a renaissance, but the term is misleading in so far as it suggests a complete renewal, a rediscovery of classical art. The activities of that age did, however, result in a broadening and widening of this current. As a result of the renewed interest in classical science and literature many antique figure-subjects were re-introduced; we find ivory caskets decorated with scenes from classical mythology, and manuscripts in which the text of a classsical poem or scientific treatise is accompanied by appropriate illustrations. The stylistic execution and the ornamental motives also frequently reveal a closer study of classical prototypes, and the works of the period are altogether on a much higher level of artistic refinement than those of the preceding ages.

At the same time oriental influences are still apparent. Byzantine art had always preserved a hieratic style apart from the classical, descriptive one. The age of Justinian had not only produced paintings and sculptures of a lively classical character, but also long rows of figures standing in a monotonous solemnity on a gold background. Thus it is not surprising to find now, side by side with that group of narrative representations to which the Nativity ivory belongs, a class of 'hieratic' ivories, mostly little altars and triptychs with figures lined up like columns in complete isolation (Plate 32). The figures are displayed on a wide empty background, they are tall and slender and betray no emotion. All signs of individual life have been suppressed, and faces and attitudes have become stereotyped.

The Crucifixion is no longer shown as a story, the narrative picture has been turned into a devotional icon.

There is in works of this kind that element of dryness and sterility often held to be a demerit of Byzantine art and conspicuous in its later derivatives in Russia and the Slav countries. The ornamental slab on Plate 34 also belongs to this category, although the strict symmetry becomes somewhat more understandable when it is realized that the relief is not a mere representation of animal life but rather a symbolical scene, the hares and the serpents being allegorical representations of man and devil respectively, overpowered by the eagle, typifying the triumphant Christ.

This dualism of 'Hellenistic' and 'Asiatic' traditions is the essence of Byzantine art. But, as our specimens clearly show, the two currents, having lived side by side for such a long time, had come to influence each other. The figures on the ivory triptych, with all their solemnity, are still the work of artists who took account of the organic structure of the body and the soft and natural modelling of folds and draperies; they show a taste for subtle and delicate detail which is typical of all the best works of the Macedonian 'renaissance'. Their rigidity is tinged with naturalism, their attitudes, although firm and austere, are yet easy and relaxed. The expression of their faces, although stereotyped and impersonal, is at the same time gentle and humane, and by thus holding the balance between solemn representation and individual liveliness they achieve an inner affinity with classical works which is in the true spirit of Byzantine art.

On the other hand, even the narrative and picturesque works have acquired something of the monumental character of the hieratic style. The Nativity relief, instead of giving a realistic view of the cave with Mother and Child, shepherds and midwife, shows all these figures arranged as a formal composition

with the Virgin as its centre. She is no longer part of the narrative, but an object of adoration with a chorus of secondary figures surrounding her. A crowd of acclaiming angels adds to the solemnity of the scene. There is a strong tendency towards the static, monumental and ceremonial. This may also be found in the portrait of an evangelist on Plate 36, which belongs to a tenth-century Byzantine book of Gospels. It contains all the elements which traditionally form part of such portraits, the chair, the writing-desk and the architectural accessories, but the latter have dwindled to a frail and slender arcade much less prominent than the wide space of empty gold ground against which the saint's head is set in solemn isolation. These wide stretches of empty background are typical of Byzantine art of the period. A relief as crowded and ornate as the Archangel diptych would be inconceivable in the tenth and eleventh centuries. The quest for the simple and the monumental is typical of all the later Byzantine works, whether hieratic or narrative. In this respect they also leave behind them all the styles evolved in the Carolingian schools, whose works seem by comparison restless and overloaded. They bear witness to a new conception of the picture and its function. Figures solemnly displayed on a spacious and neatly framed panel are monumental rather than pictorial. They are not merely an accompaniment to a text but are offered to the spectator for worship and edification. The renewed cult of images after the iconoclastic period may be at least partly responsible for this change, the eventual outcome of which is the Russian icon.

But the new dignity and solemnity were essentially a matter for the court. The monasteries, especially in the remoter parts of Asia Minor, and even in the capital, continued to cultivate their taste for lively and realistic representation. In fact, this style, which we have seen to be typical of the monastic art of Asia ever since the early Byzantine period, now flourished more

than ever. On a page from an eleventh-century Psalter (Plate 35) the Israelites are seen gathering the manna and roasting the quails which God had sent them. These minute and lively scenes, strewn loosely and unconventionally over the margin of the text, are the only illustrations in this book of a style which had been practised in those regions for centuries.

We may now return to the West. In the second half of the tenth century the style, or rather styles, imposed upon the Western world by the official schools established under the Carolingian emperors, were superseded in several countries by fresh, spontaneous efforts. The empire of Charlemagne had fallen asunder, and from its ruins individual nations had begun to emerge. France and Germany had begun to live separate lives under different ruling houses. The other European countries, faced with their own particular problems and struggles, gradually assumed distinctive national features.

The political separatism of the period has its counterpart in art-history. There is no longer an international European art. As opposed to the Carolingian styles, the new movements of the late tenth century are all associated with individual countries where artists began to create their own styles. If we look at Plates 26-31, which show specimens of tenth- and eleventh-century work from England, Germany, Italy and Spain, we see at a glance how different the results were.

It is a curious fact that all these separate styles, although apparently not connected with each other, emerge more or less simultaneously. The collapse of the Carolingian empire had left vast parts of Europe in a chaotic condition, to which the various barbaric invaders, especially the Huns in Central Europe and the Danes in England, had further contributed. As opposed to this the late tenth century is in many respects a period of reorganization. Most important, perhaps, from the

art-historian's point of view, is the monastic reform which then found vigorous champions in the monks of Cluny and spread to many European countries. In England, France and Italy, at any rate, the revival of the arts is due to the spontaneous efforts of the reformed monasteries, and this accounts both for the movements being simultaneous and for the individuality of styles in the various countries. In Germany an additional stimulus was provided by the revival of the imperial power under the Saxon dynasty, and since many of the outstanding works of the period between 970 and 1050 owe their existence to the patronage of the emperors from Otto I onwards, this whole phase of German art is usually known as the Ottonian period.

English art at that time entered upon one of the most significant phases of its history, one in which the creative genius of the island blossomed forth as it had done only once before in the days of the Early Church. Carolingian art had not found a ready response on this side of the Channel. Afterwards the Danes had come, and for nearly a century English art consisted of a mixture of debased Carolingian motives and Scandinavian animal ornament, which are characteristic features, for instance, of the West Saxon crosses of that period. It is difficult to say why in the late tenth century this flame was so suddenly kindled. While St. Dunstan's monastic reform had prepared the ground, it does not account for the artistic invention, which within hardly more than a decade evolved a new and original style, so highly finished and elaborate from the beginning that it would seem to be the result of a long and gradual development.

The foremost place in the art of the period is taken by the Winchester school of painting, which, during the last decades of the tenth century and the earlier part of the eleventh, produced a series of splendid illuminated manuscripts. The artists obviously used Carolingian works as models. Some of the

figure-compositions of the Winchester school are found in
ivories of the Metz group; the restless folds of the draperies,
with their outlines drawn with a nervous hand, remind us of
certain figures of the Ada school (Plate 18). The sprigs of
acanthus playing freely about the frame, which are a hall-mark
of the Winchester style, are found in a group of Carolingian
manuscripts associated with Metz.

From the outset, however, only such motives are chosen as
fit in with a preconceived notion of a new artistic effect. There
is an entirely new relationship between figures and ornament,
which is never found in Carolingian works. The frames in
the early Winchester manuscripts are unusually broad and
heavy. They are much more than a mere border for a figure-
scene; they form an essential part of the composition. Very
often the figures actually stand on the bars of the frame or seem
to grow out of the foliate ornament. In other cases, as, for
instance, in the portrait of St. Luke in the Grimbald Gospels
(Plate 28), the connexion between figures and frame is more
subtle; here the rich baroque sprigs of foliage on the frame exert
a kind of magnetic attraction which keeps in balance the figure
floating freely in indefinite space. At any rate figures and orna-
ment are always closely linked up with each other. They seem
to be made of the same stuff; they have the same ruffled surface,
with flickering little lights playing over it, and outlines as
unsteady as though they were flames shooting up incessantly on
all sides. The St. Luke page is not merely a portrait; it is at the
same time a large and sumptuous openwork ornament on a
blank ground.

In other words the artist returns to the principles which
guided the painters of the Irish and Northumbrian manuscripts
of the seventh and eighth centuries. We found in the Lindisfarne
Gospels figures floating in an empty space and grouped
like an openwork ornament. By entirely different means

a similar result was again achieved in the tenth-century manuscripts.

It may be contended that a deep-seated national instinct made the Winchester artists treat their Carolingian models in a spirit so closely akin to that of early Northumbrian miniatures. But there were also more concrete links between the two periods. For one thing the earlier manuscripts themselves were available. An eleventh-century Gospel-book in Copenhagen has an evangelist's portrait based on one of the illustrations in the Lindisfarne Gospels. More important than this significant but isolated case of antiquarianism is the living tradition of insular art in the Franco-Saxon school of miniature-painting (see above, page 49). There we find the ornamental pages of the Irish and Northumbrian manuscripts perpetuated in the ninth and tenth centuries. Although the details of the Winchester miniatures are all new and different, their scheme is still the same as that of a Franco-Saxon page (Plate 21). Both have the same framework, in one case filled with abstract knot patterns, in the other with acanthus- and figure-work. These details are hardly more than accessories; the skeleton of the page is still the old insular design of a heavy frame with large ornamental corner-pieces, which found its way to the Continent in the ninth century and now returns. Some Franco-Saxon manuscripts show the old interlace and animal ornament replaced by Carolingian acanthus and human figures, and these foreshadow the Winchester miniatures even more closely. Many details of the ornament of the Winchester miniatures are also derived from the Franco-Saxon group. Some of the initials are practically identical with those occurring in Franco-Saxon manuscripts, and the panels of acanthus frieze which are found, for instance, on the borders of the Grimbald miniatures also have their closest parallels in that school.

The ornamental character of the Winchester manuscripts is

thus accounted for by an uninterrupted tradition of the old insular style. Yet we hardly do justice to these paintings if we regard them as mere ornament. There is, on the contrary, a great deal of movement and animation in them. Figures are shown gesticulating vigorously, their heads are turned upwards or sideways, their garments flutter in all directions. It is not a liveliness emanating from the figures themselves, it is rather an outlet for the painter's own exuberant imagination, so much so that it does not stop short at the figures but also pervades the foliate ornament. The whole page is in a state of vigorous excitement, as though a storm were raging over it.

The source of this nervous expressiveness of the Winchester miniatures is often thought to lie in the illustrations of the Utrecht Psalter. But although this manuscript is known to have been in England in the late tenth century there are no signs of any direct connexion with the early manuscripts of the Winchester school. It is more correct to say that the two groups of artists of Rheims and Winchester were informed by the same desire for intense animation. This inner affinity, however, made the English artists extremely susceptible to the influence of a work like the Utrecht Psalter, and it is therefore not surprising to find that this manuscript subsequently became very important for English miniature painting. There is, in particular, one group of manuscripts which shows many signs of the influence of the Utrecht model, namely those with illustrations in outline drawing made in various English monasteries and also at Winchester from the late tenth century onwards. The Harley manuscript 603 (Plate 29A), which was executed in St. Augustine's, Canterbury, about the year 1000, has already been mentioned as a direct copy of the Utrecht Psalter. It is the chief witness to the influence that the Rheims style exerted on English draughtsmen, and at the same time it shows how thoroughly

this nervous and excited manner agreed with their own intentions. They would never have been either willing or able to give such a faithful rendering of a style so difficult and seemingly inimitable in its delicate impressionism, had it not contained what they themselves desired to express.

Most English drawings of that period are strongly influenced by the Utrecht Psalter, although the degree in which the style of the original has been followed varies considerably. Plate 29B, also from a Canterbury manuscript, shows many typical features of the Utrecht style, the curved bodies, with their round shoulders and protruding heads, the vigorous gestures, the triangular shape of the eyebrows, the peculiar pen-drawing technique, with its sudden changes from very delicate to very thick strokes, and the expressive spiral and zigzag lines which represent the ground. But all these features have been exaggerated a little, and there is a touch of the grotesque and fantastic.

It is only in its later stages that the Winchester school of coloured full-page miniatures also shows the direct influence of the Utrecht style. Figures become less stolid, their outlines are more sketchy and intermittent, their heavy body-colour is often replaced by a lighter shade. They also begin to show the same protruding heads, round shoulders and exaggerated gestures which are found in the outline drawings. But these features merely accentuate the expressiveness which is characteristic of the Winchester school from the very beginning.

This expressionist tendency is a fundamental characteristic of English tenth- and eleventh-century style in addition to its markedly ornamental bias. With all the figure-subjects and decorative motives of his Carolingian forerunners at his command the English artist pursues a double course, and he pursues it with a vigorous independence which they would have found impossible. It is, perhaps, his greatest achievement that he

succeeds in combining the two tendencies which in Carolingian times had been separated and associated with different schools. In the Winchester miniatures it is impossible to draw a line between ornamental and narrative elements. All parts of the picture are fused. The details which Carolingian artists had accumulated were melted down to form a new unity which was at once thoroughly ornamental and full of inner life.

German Ottonian art, contemporary with this great period in England, affords both parallels and contrasts. It is an art largely sponsored by kings and emperors, more pretentious and monumental, and wider in its scope. While in England comparatively modest Saxon churches were built, the German rulers embarked on great cathedrals, such as Speyer, Mainz and Bamberg, all of which have foundations of the Ottonian period. There were many monasteries founded or patronized by the emperors, and some of these, especially that on the island of Reichenau, in the Lake of Constance, became great and important centres for all kinds of artistic activity. In addition to imperial patronage great encouragement for artists came from some of the bishops, who were beginning to develop into powerful lords in their respective territories. On their own account they built churches and commissioned all kinds of objects, such as illuminated manuscripts and church furniture of bronze and precious metals. Bernward of Hildesheim and Egbert of Trier are prominent among these ecclesiastical patrons of the arts. The result is that in Germany there are many more centres with a distinctive style of their own, and there is a greater variety of different crafts including monumental bronze sculpture, fresco painting and goldsmiths' work.

German art is also based on Carolingian models, but its style is quite different. While the English favour baroque exuberance, diffuse outlines and rich ornament, German Ottonian art

is rigid, stern and monumental. This style had been fore-shadowed in the late Carolingian period and, unlike England, where an entirely new start was made in the late tenth century, Germany possessed a living tradition of Carolingian art, repre-sented by such works as the Metz ivories (Plate 23), in which the Ottonian style had already begun to take shape. We notice a preference for heavy block-like figures, isolated from each other, and for regularized, simplified compositions. The con-tinuation of this manner in the Ottonian period is well illus-trated by a work like the ivory relief on Plate 26. It shows Christ raising the Widow's Son and, together with a large number of similar plaques scattered over various European museums, probably once formed part of the decoration of an altar. Made about the year 1000, either in Milan or on the island of Reichenau, it is obviously related to the Metz ivories, but it shows all their conventionalisms strongly intensified; the figures are stiff and massive, the draperies simple and straight, the hands clumsy, the heads large and globular, and the eyes staring. Most significant of all is the openwork pattern which serves as a background and shows the extent to which abstract tenden-cies had reasserted themselves. It gives an element of unreality to the scene, but the figures themselves are so strongly stylized that no contrast is felt to exist between them and their setting.

As also happened in England, certain groups of German miniature-painters of the Ottonian period went back to the original Carolingian works of the ninth century, thus pro-claiming in the domain of art the revival of imperial power which was the political programme of the time, but they did not select elements from different Carolingian models to combine in a new organism. They clung faithfully to a parti-cular set of models, and it is significant that the works most favoured were those of the Ada school, belonging to the German rather than the French part of the Carolingian Empire,

and associated, moreover, with the court and regal ceremony. The linear and rigid style of the Ada school, with its figures firmly enclosed in architectural settings, suited their taste much better than works in the manner of the Utrecht Psalter. They added to its monumentality by eliminating some of the ornamental details in which the Ada manuscripts were particularly rich. They substituted simpler geometrical forms for the elaborate foliate capitals, and by generally suppressing unimportant details which might distract the eye from the great lines of the composition they gave clear proof of a new and independent artistic conception.

Their preference for monumental types received further support from Byzantium, an influence easily explained by the close family connections between the Ottonian dynasty and the imperial court of Constantinople. In ivory carvings, for instance, we now often find stiff isolated figures with a wide empty background and the typical Carolingian book-cover, with its whole surface crowded with narrative scenes, seldom occurs. Single scenes filling a whole panel, wide stretches of neutral background, broad frames, are all features equally characteristic of German Ottonian and of contemporary Byzantine art. Where the background is given more prominence through elaborate ornamentation, as, for instance, on the Reichenau ivory panel, the Byzantine influence is particularly striking; the gold plaque from Asia Minor (opposite page 1) may be quoted as a parallel.

Yet an increasingly abstract and monumental quality is not the only characteristic of Ottonian art. In Germany no less than in England artists of the period were impelled by an overmastering desire to fill their pictures with emotional content. Nowhere is this feature more prominent than in the illuminated manuscripts of the Reichenau school, which are the great masterpieces of Ottonian art.

The earliest works of this school, dating from about A.D. 960 to 970, follow closely the manuscripts of the Ada group. But very soon the artists became tired of illustrating their Gospels with the portraits of the four evangelists, which are the habitual decoration of Ada manuscripts. Moreover, it is the period in which the *Pericope* makes its appearance, a book containing the Gospel texts, not in their original sequence, but arranged according to their place in the liturgy. In books of this type author-portraits had no scope at all. New types of illustration were called for, and were found in elaborate pictorial cycles. In the Carolingian period New Testament scenes had been largely confined to the ivory book-covers. In the same degree as the narrative scenes are superseded on the bindings by more solemn and formal figures, so inside the book Bible stories are now displayed with the liveliness and richness of detail which brush and colours alone are able to give. In composing these the artists found a model in the cycles of illustrations in Early Christian and Byzantine manuscripts. The stories of Christ's childhood, His miracles and Passion, are adapted from these models, and from them the Ottonian miniatures inherit a wealth of narrative detail and secondary figures to accompany the main events. The scene of the Washing of the Feet, for instance, always includes, besides Christ and St. Peter, a group of apostles, one of whom is seen untying his sandals in expectation of a similar service from Our Lord; and by the side of Lazarus's tomb we regularly see a man covering his nose with a handkerchief, a vivid suggestion of the stench issuing from the corpse. Such figures, of which Mediterranean book-illumination included a great number, gave the Ottonian painters a wide scope for their expressionistic tendencies. In certain Mediterranean manuscripts, it may be noted, and especially in those of Asia Minor, these dramatic qualities are already fairly developed, and if German Ottonian figures seem to speak with their hands rather

F

than with their mouths, if their eyes protrude from their sockets with the pupils turned to their extreme angles, if figures are curved and twisted by emotion, and arms and legs undergo the most incredible contortions, it is in Asiatic miniatures that they find their closest parallels.

This vigorous expressivenesss is no less characteristic a feature of Ottonian art than its severely monumental character. But its greatest significance lies in the manner in which the two purposes are combined, an achievement of which the Reichenau miniatures are the most splendid illustrations. The Asiatic artists, to whom they are so largely indebted, had already begun to reduce the background scenery to a minimum and to place figures against a plain neutral ground. This is quite in accordance with the abstract style of the Ottonian painters, who, however, set off their figures even more strikingly by making their outlines clear, simple and inflexible. Moreover, the composition is often severely symmetrical. Even the most animated figures always form a perfectly balanced group of geometric simplicity. These stylistic conventions, which are typical of Ottonian art, far from reducing the emotional appeal of the figures, actually increase it to the highest degree. The simplicity and clearness of a figure's outlines make its twists and bends all the more expressive. The simplification of the background increases the effect of movements and gestures; as each figure or group is set in isolation against a pure vacuum, the emotions expressed by the eyes and hands are the only link between them. Finally, the abstract regularity of the composition sets the liveliness of the individual figures in even stronger relief and at the same time makes them appear free from all the accidents of physical life. They conform to a higher, supernatural order of eternal validity.

It is the contrast between emotional passion and a framework of monumental coldness and dignity that makes these paintings

so effective. Between them these two tendencies have entirely transformed the Mediterranean or Carolingian models. Descriptive forms have no longer any intrinsic importance; bodies are, as it were, consumed by their inner fire and at the same time bound by abstract laws. Polarized between these two magnets matter has lost all its natural gravity. An artistic form has been found capable of expressing the purely spiritual and transcendental, a power that classical art had never possessed. Some of the Reichenau miniatures almost suggest that they had been created in a state of religious ecstasy, as though they were the record of a visionary's dream. Although so many of their elements are taken over from works of earlier periods, they achieve a directness and a fervour of expression which makes them rank among the greatest triumphs of medieval art.

The miniature on Plate 27 can give only a rather faint impression of the magnificence of these pictures. It comes from a manuscript executed at Echternach, a monastery whose miniaturists were closely affiliated to the Reichenau school, and it shows hard, simplified figures with lively gestures standing out against a neutral ground. It also shows a perfectly balanced composition, where the city architecture, which in the Early Christian archetype had undoubtedly formed a realistic setting for the Annunciation, has been turned into a heavy frame encircling the figures and raising the narrative scene to the status of a monumental group.

It would hardly be possible to conceive a style more strongly opposed to the English work of the period. While Winchester miniatures are exuberant and overflowing, the German ones have a firm and steady structure. While in England outlines are diffuse and nervous, here they are sharp and crystal-clear. There is contrast also on the emotional side. While the expressive character of a Winchester page is a reflection of the artist's own temperament, here it is intimately bound up with the dramatic

content of the scene. The artist retires, as it were, behind his subject, and the figures play with great liveliness the part assigned to them in the drama. English miniatures, however lively, have much less specific content. Human shapes are apt to lose their individuality in the general turmoil of nervously drawn outlines. Further, while in the German works, with their tense austerity and dramatic pathos, there was no room for a rich display of ornament, the English painters allow masses of ornament to play freely about the figures. They found in it as good an outlet for their excitement as in the human figures. Of course, their excitement is religious, and Winchester art is a religious art in the true sense of the word. But as for illustrating the special characteristics of any Biblical text, the Winchester miniatures do that almost as little as the pages of animal ornament which the insular artists had painted three hundred years earlier, whereas the German creates a vision of a definite religious event.

But with all their expressionistic character the German works also have a definite ornamental value. They owe it to the abstract structure of their composition, and to the sharp contrasts of figures and background. In fact, in spite of all their differences, German and English styles of that period have one fundamental point in common: in the German works as in the English it is impossible to say where illustration ends and ornament begins. If the Reichenau miniatures may be taken as ecstatic visions of sacred scenes, they may also be taken as large ornamental patterns. In them the severe architectural style of the Ada school is contained no less than the emotional vigour of the Utrecht Psalter. In a manner entirely different from the English the Germans succeeded in combining the twofold aim which both had inherited from Carolingian art.

German and English art play the leading parts in Europe in the

tenth and early eleventh centuries. France did not develop its
Carolingian traditions in the same way into a specific national
style. French artists continued to some extent to copy the works
of the Carolingian period; they also took over the contem-
porary styles of their neighbours ready-made. Thus we find
much English and Ottonian influence in Northern France,
while in the South there is an entirely different style which can
only be accounted for by the proximity of Spain. The French
showed, even at that time, a keen appreciation of subtle and
delicate forms, but it was not until later that they began to
display an artistic activity so vigorous, original, and many-sided
that they became the teachers of architects, painters and sculp-
tors all over Europe.

Italy and Spain, however, both have a clearly defined style of
their own, each markedly different from anything produced in
Northern Europe. The course of development in these coun-
tries differed entirely from that of the North. Both had an
uninterrupted tradition of Christian art from late Roman time
and there was no scope for a Carolingian Renaissance. In fact
that movement had only very slight influence south of the
Alps and the Pyrenees. Except in a few cases which must be
classified as direct offshoots of Carolingian art, we neither find a
strong ornamental element, such as rich acanthus foliage or
heavy architectural decoration, nor the exuberant expressive-
ness of Northern works. The miniatures, which here again are
the most important and most characteristic evidence remaining
to us, show a much simpler and more sober figure-style. Based
on Early Christian models, they display the somewhat primitive
manner which Rome and the West Mediterranean countries
in general had evolved at that time. The tendency towards flat
two-dimensional representation and linear technique, which
had been characteristic of these countries ever since the Early
Christian period, had increased in the intervening centuries, and

the result is that Italian and Spanish works appear much more archaic than the contemporary Northern monuments.

An example of Italian work of the eleventh century is the miniature of Adam and Eve on Plate 30. It is taken from an illuminated manuscript in scroll form bearing the text of the Easter Ceremonies. These so-called Exultet Rolls are a speciality of South Italian artists of that period. They are a typical product of the revival of monastic civilization which all Europe experienced from the late tenth century onwards. The chief centre in Italy of that revival was the old Benedictine foundation of Montecassino, and it is from there that our manuscript comes.

The Montecassino paintings show very clearly the persistence of the simple linear style which Italy had evolved during the Early Christian centuries and which during the eighth and ninth centuries had chiefly survived among the fresco-painters of Rome and Southern Italy. Figures drawn entirely in outline and covered with a layer of unshaded body colour are typical of this style. There is no trace of the animation found in contemporary Northern work. The artist does not try to express all his religious passion in every stroke of his brush. He draws his figures with a firm and steady hand. They are often stiff and flat, but always clearly and neatly outlined. If there is any scenery it is also strongly simplified and usually consists only of isolated houses or trees. But these are firmly planted beside the figures and add to the solidity of the composition. The way in which the two figures on our miniature are framed by the two trees on either side is typical of the sense of symmetry and architectural composition which Italian artists had possessed ever since Late Antique times.

At the same time the treatment of the nude betrays great familiarity with classical designs; it shows a softness and elegance with which one would hardly have credited an Italian artist of

that period. The truth is that our miniature no longer represents the Italian tradition in its purity. After having started about the year 1000 in the very stiff, angular manner of the preceding centuries, the monks of Montecassino, in the second half of the eleventh century, turned their eyes towards Byzantium. The great abbot Desiderius (1058–1087), under whose ægis our manuscript was painted, procured painters, sculptors and masons from the East, and thus the gates were once more open to a steady stream of Byzantine influence, which, as so often in the history of early medieval art, meant an increase of naturalism, a freer, easier and more organic style, a return to something like classical beauty, qualities which our figures of Adam and Eve clearly possess. And yet a comparison of this miniature with genuine Byzantine work shows how much it retains of the linear simplicity traditional in Italian art.

Perhaps the strangest flower in the whole vast field of early medieval art is that which grew up in Spain during those same centuries. Spain gives an example of Christian art developing from, but never renewing its contact with classical traditions. Not only was it never reached by the Carolingian Renaissance, it also remained outside the sphere of Byzantine influence. In Early Christian times, when the Roman Empire still held together, we find Spanish sarcophagi in the Roman style, and Spanish artists probably also took part in the early development of Christian book-illumination; but afterwards Spain remained completely cut off from classical sources.

Instead of this there were influences from various regions of a strongly anti-classical style. It is likely that Coptic art found its way to Spain via North Africa as early as the sixth century. Not much later, barbaric elements came across the Pyrenees from Merovingian France. But most important of all was the close contact with Islamic art established through the Arab

invasion early in the eighth century. The Southern half of the country fell entirely under Arab domination. In the North, in Catalonia and the Asturias, Christianity persisted, but it absorbed many Islamic elements.

The result is most clearly seen in the so-called Beatus manuscripts, the most famous and the most peculiar product of Spain in the early Middle Ages. These are illustrated editions of a commentary on the Apocalypse written by the monk Beatus of Liebana (A.D. 786). The extant manuscripts date from the tenth to the twelfth century.

The painters did not invent their pictures: they probably had before them illuminated copies of the Apocalypse of sixth- or seventh-century date. But at that time Spanish artists had already drifted away from the general line of development of Western art, and had eliminated many classical elements. Even in those days Spanish art had, in fact, acquired a somewhat exotic flavour, as is seen in the miniatures of the so-called Ashburnham Penta-teuch in the Bibliothèque Nationale, Paris, which comes either from Spain or from the neighbouring coasts of North Africa, and the prototypes of the Beatus manuscripts probably showed a similar style. The events of the intervening centuries, how-ever, had increased these tendencies a hundredfold. Everything in the Beatus pictures is absolutely flat: there is no indication of depth or of a third dimension in the composition, no plastic modelling in the figures. They are as thin as paper, there are no folds in their garments, their movements are angular and rigid, their faces are drawn with a few straight lines. But in addition to these barbaric elements there are many features of Islamic origin. Not only is there a profusion of Arabic ornament, such as horseshoe-arches, heraldic animal patterns, and Cufic letter-ing, but the fact that figure scenes are treated like ornament and strewn with a variety of patterns as though they were a carpet (Plate 31) is also in accordance with oriental taste. There is a

completely non-naturalistic colour scheme. Only strong, out-spoken tones are used, and the painters take a delight in dazzling contrasts, red and yellow being specially favoured.

Often, too, this style, with its purely ornamental interpretation of the outside world, reminds us of Irish art, and there are many striking similarities between the two. But it is doubtful whether these are due to any direct Irish influence in Spain, or merely to the oriental elements which both countries had absorbed.

What is certain is that the Beatus manuscripts represent, as does Irish art, the purest concentration of anti-classical currents in the early Middle Ages. Therein lies their significance, and also their limitation. It is a one-sided art, the very extremity of stylization and conventionalism. It lacks the possibilities of further development that England, France, Germany and Italy derived from their renewed contact with the classical tradition.

The different styles evolved in the various European countries during the tenth and eleventh centuries find their explanation partly in different foreign influences, which in their turn are largely due to political circumstances, partly in the peculiar æsthetic inclinations of artists in the various regions. There is no longer an art representative of all European such as Carolingian art had been in the preceding period. Yet all these national styles have something in common. Whether we take a miniature from Winchester or one from Reichenau, whether we look at an Italian or a Spanish work, compared with Carolingian works they all show a grander, simpler and more monumental conception. There is nothing of that *horror vacui* which made Carolingian artists fill every inch of a miniature or a book-cover with figures or ornament. Vast, empty backgrounds are typical of tenth- and eleventh-century style in all countries. Artists still copy from Late Antique models, but no

longer so timidly and conscientiously and on such a minute scale as the Carolingian miniaturists and ivory carvers. They take a more independent view of their models, boldly conceiving new compositions with large-scale figures and space between them, monumental and austere compositions which fill the whole page or panel or wall.

Even Byzantine art, although based on different traditions and separated from the West by many barriers, aimed at similar effects during these centuries. There, too, there was, as we have seen, a turn towards the hieratic and the monumental, although the stylistic forms are quite different.

To some extent these fundamental similarities may be due to direct historical connexions between the various Western countries and Byzantium. Byzantine influence plays an important part in Germany, and it may also have contributed to the making of tenth-century style in England. Yet the monumental tendency expresses itself in so many different ways in the various regions that it can hardly be accounted for by direct influences alone. There were, however, during those centuries certain general developments common to all countries, and the most important of these is the increasing influence of the Church. Whether in antagonism to the secular rulers as in the West or in co-operation with the emperor as in Byzantium, the Church then attained formidable power, which it henceforth held throughout the Middle Ages. The Latin Church, particularly, having sunk to a very low level in late Carolingian times, underwent a process of purification, largely as a result of the activities of the reformed monasteries, and greatly increased its moral hold upon man. Art, however, served as a means of bringing home to the faithful the binding force of the Christian dogma, and that is, perhaps, the root of the monumental character which it then began to assume throughout the Christian world.

The need for expressing and propagating transcendental truth once more turns the scales against the classical tradition in art which came so much into prominence during the Carolingian period. The tenth and eleventh centuries, however, mark only the beginning of the new movement; its full consequences became visible in the Romanesque art of the twelfth century.

TWELFTH CENTURY
ROMANESQUE ART

IT is difficult to draw an exact line between the period with which we have just been dealing and the Romanesque period which followed it. Many characteristics of twelfth-century style, heaviness, monumentality and rigidity, are the direct result of the development in tenth- and eleventh-century art, which, in fact, is often known as Early Romanesque. The Reichenau ivory of about A.D. 1000 (Plate 26), for instance, has a strong Romanesque flavour, and Southern French and Spanish works with their archaic character are *a priori* akin to the new style.

If the development of figure-art were alone to be taken into account it might be a question whether we should break the continuity of the story altogether at this point. Romanesque is, however, primarily a term for an architectural style, and it is above all in the history of architecture that the second half of the eleventh century marks an important turning-point. It is true that there had been cathedrals before that time, which foreshadowed Romanesque architecture, even in certain stylistic features. But now the great building period begins all over Europe, in France, Germany, Italy, and Spain, and also in England, in which country the break between the old and the new period is particularly marked, since it is at the same time a break between the Saxon and the Norman periods. It is not, however, the number and the size of the buildings alone which marks a new movement. A fresh departure was also made in the matter of style. Romanesque architecture is commonly recognized by its round arches. But a more significant fact is that here, for the first time in medieval architecture, an attempt was made to

subordinate all parts of a building to a uniform system. The walls are articulated horizontally by means of tiers of arcades, galleries, and windows, and vertically by means of pilasters, which divide the whole length of the walls into a number of equal sections. And not only is the individual wall thus organized: the problem which more than any other occupied the minds of the architects of that period was that of linking up opposite walls by means of vaults. The low-pitched wooden roof hitherto chiefly used in Western basilicas had been a plain and inorganic cover to the nave. The vaults by which architects now succeeded in spanning the whole body of the church actively connected the walls on either side, and as these vaults were subdivided into a number of bays, each of which connected two opposite sections of the wall, the whole nave is turned into a series of well-ordered compartments which follow each other with impressive monumental rhythm.

The plain assembly-room, which had originally served the Christian Church, with its plan and structure determined by classical precedents and practical utility, is thus turned into a new and complicated architectural organism, not governed by any utilitarian considerations and comparable in its self-imposed severity to the structure of a musical composition. It becomes a kind of fugue, an architectural hymn, a manifestation of the glory of God.

It almost necessarily follows that this type of building, with its arcades, pillars, and columns should give birth to sculptural decoration on a large scale, such as had not been known in European art since classical times. The hymn cannot do without words, and the monument must have a message. Grave and dignified figures grow out of the pilasters on either side of the porches; lintels and tympana are covered with reliefs; on capitals, friezes, corbels and many other joints of the architectural skeleton figure-sculpture appears. The figures have a

definite place in the structure, they are themselves composed according to architectural principles. At the same time the architecture becomes a framework for the sculpture and an integral part of the message it carries. If the arches of a cathedral porch are supported by statues of the apostles, which in their turn stand on the shoulders of prophets, it is a symbol in stone of the Christian Church resting on the firm foundation of the Old Testament. When Christ as Judge of the World is seated in the tympanum over the door it means that the faithful have to pass before His judgement-seat to be allowed to enter His house. The Old and New Testament stories, carved in stone in long rows on the capitals of the columns on either side of the nave, are the divine revelation on which the walls of the Church rest. The cathedral proclaims in a concrete and visible form the dogma of the Church. It is the Gospel in stone.

Architecture and sculpture are thus fused into an indissoluble unity, both in æsthetic and a symbolic sense, and the same applies to all other forms of decoration. The building is an organism of which no part can be fully understood unless seen in relation to the whole. The subordination of all details to a monumental scheme is the most significant feature of Romanesque art.

In the seven or eight centuries which had elapsed since the end of the classical period the minor arts had often played a more prominent part than architecture and the kindred crafts. It is possible to give a fairly accurate picture of the early stages of Christian art by relying chiefly on such works as miniature paintings and ivory carvings. In the Northern countries particularly, with their traditional preference for portable works of art, these small and independent objects were much favoured by the Christian Church. But from the latter part of the eleventh century, architecture, large-scale painting and sculpture, come to the fore. A museum exhibition case with small and isolated

objects of the Romanesque period is not so representative of its subject as a case illustrating the arts of the preceding centuries.

This limitation must be borne in mind when looking at the specimens of Romanesque art illustrated in this book (Plates 38–47). Some of them are supreme examples of twelfth-century craftsmanship and serve to illustrate certain of the characteristic features of Romanesque style. But they do not fully represent the style, nor do they suffice to illustrate the various currents in the historical evolution of the period.

It is, however, possible to give, with the help of these objects, a general description of the new art, whose principle manifest themselves in the minor arts no less than in architecture and stone sculpture.

Thus the quest for the monumental is not confined to churches and the larger sculptures. This feeling pervades even the small objects of the period. The ivory chessmen from Lewis (Plate 41A), though the largest is only four inches in height, have the characteristics of colossal stone carvings, and may serve as types of Romanesque figure-art generally. They show all forms reduced to their simplest elements. The few parallel lines left to indicate the flow of the garments are like an ornament incised on a massive block. The figures seem to be a heavy mass compressed into the smallest possible space. Concentrated weight is their chief feature. The eyes are like openings in the surface of the block, through which the stored energy of the internal mass thrusts outwards.

Many other works of the period show similar qualities. Figures are usually short and heavy; in many cases their features and the folds of their garments are indicated by a few lines forming a kind of ornamental network over a mass of shapeless material.

The chessmen are composed on strictly symmetrical lines, and present a more or less flat front to the spectator. This, too,

is typical of Romanesque art. In reliefs, for instance, figures are spread out in the simplest possible manner on a plain background. The third dimension is ruled out completely. Instead of this the background is often divided into ornamental stripes.

In view of these peculiarities Romanesque art is often called archaic, and there is undoubtedly an air of primeval vigour about many of its creations. Moreover, we often find in it the supreme neatness and technical purity that we associate with archaic art. Every obligation to realism has disappeared; figures are designed in a purely abstract manner and acquire the exactitude and regularity of an ornament. The artists, no longer tied slavishly to their Late Antique models, draw their figures with complete freedom and with a feeling for the ornamental beauty of lines and curves that seems like a revival of one of the greatest virtues of North-European art in the pre-Carolingian age (Plates 43, 44, 46, 47).

But while the term 'archaic' implies an initial stage, the primitive appearance of the Romanesque style is the final outcome of a long and complicated development. Indeed, we saw its features evolved in the art of the tenth and eleventh centuries. It is merely a development ending in the supremacy of the tendencies apparent in European art of post-Carolingian times. We have seen simplified geometrical compositions, plain backgrounds, block-like figures with stylized draperies and geometrical outlines gradually developing in German Ottonian art. On the other hand, we have found even more conspicuous features of primitive art than those of most Romanesque works to be inherent from a very early stage in the art of Spain and its offshoots in Southern France. This art, with its archaic robustness, is particularly important as a source of Romanesque style, more so in some respects than Ottonian art, which on the whole avoids heaviness and concentrated weight. Thus it is not surprising to find that the earliest large-scale architectural

sculptures of the Romanesque period occur in this South-West region of Europe, in Languedoc and Northern Spain. How much these sculptures owe to the previous development in Spain is shown by their numerous iconographical connexions with the Beatus manuscripts. There is therefore a strong direct link between the extreme form of primitive style in tenth- and eleventh-century art and the Romanesque art of the twelfth. But all European countries had, to a greater or less degree, inclined to static monumental representation during those centuries, and the development between the ninth and the twelfth centuries may be broadly described as a transformation on a large scale of classical naturalism into abstract regularity, of which the Romanesque primitive style is the final result.

Romanesque archaism is therefore the outcome and not the initial stage of a development. Moreover, the word 'archaic' by no means covers all the aspects of twelfth-century style, for it has many features which can only be described as highly mature and sophisticated. This applies particularly to the structural system of buildings and their decoration. Among the objects here illustrated is at least one which is part of an architectural scheme, a capital from Lewes Priory (Plate 40), which may give some idea of the subordination of figure-sculpture to architectural forms. The Miraculous Draught of Fishes is here represented in a strictly symmetrical composition and the figures seem to have assumed the structural function of the volutes which in a classical capital act as a link between the column and the wall above.

Even small and independent objects reflect something of this genius for systematic construction. A manuscript page or a metal object is now a self-contained whole, and part of a consistent scheme. As the statues and reliefs adorning a cathedral are subjected to architectural rules, all the component parts of a painting or a small carving are subordinated to a fixed plan.

G

The beautiful cross enamelled by Godefroid de Claire (Plate 38), with its figure panels at each end and in the centre, and the ornamental panels separating them, is a good example of this. A Carolingian, and perhaps even an Ottonian artist would have filled the whole of the cross with a series of narrative scenes which would have made us lose sight of the underlying geometrical form. Ornament would have been used merely for framing the scenes in accordance with classical principles. For the twelfth-century artist, figures and ornamental panels are of equal value in a rhythmic order intended to accentuate the form of the cross, and to articulate it, as though it were the ground-plan of a building.

This subordination of all the elements to a common order is best seen in the miniature paintings of the period. It is very significant that the most favoured form of manuscript decoration at that time is the historiated initial. Elaborate ornamental initials at the beginning of an important section of a text had been a favourite device of book-illumination in the North ever since the great period of Irish and Northumbrian art. We saw that pages with figures were added as soon as contact had been firmly established with the Mediterranean world. But except in a few isolated cases pre-Romanesque miniaturists had never united the two elements. The painters of the Winchester school had achieved a fusion of figures and ornamental framework, but only in full-page miniatures carefully separated from the text. Not until the Romanesque period do text, illustration, and ornament become part of a regular scheme. On Plate 42, two figure-scenes, the Creation of Light and the Creation of Eve, are included in an ornamental framework of scroll and interlace patterns, and we do not at once realize that the whole composition is nothing but the letter 'I', which, with other letters arranged on either side and partly interwoven with it, forms the opening words of the first chapter of Genesis, the

text of which is continued on the right half of the same page. Every book of the Bible is headed in this way, not by a separate miniature-page, but by a composite design of text, ornament and illustration all in one. Miniatures are thus built into the text; they are no longer separate leaves but are fused with the script into one indissoluble unit. They are corner-stones, intended to emphasize the structure of the sacred text. Nowhere is there a more apparent desire for large-scale organization and architectural order or a greater aversion to anything loose and indefinite.

It is that spirit in which goldsmiths and other metalworkers designed censers, chalices and other liturgical objects in architectural shape. We may note especially the domed reliquaries of the Romanesque period, and the shrines in basilica form. In many cases they were probably meant to symbolize a sacred building. But at the same time the aim was not to produce realistic imitations of houses or churches in a miniature scale. What may be called the doll's-house taste does not develop until the end of the Middle Ages. In the Romanesque period the artists were concerned with monumental rather than realistic effects. This is shown by the censer-cover on Plate 39. A structure vaguely comparable to a church with four equal arms grows out of an ornamental plant-scroll, while four figures of angels and four evangelist symbols (all much too large to be regarded realistically as inhabitants of the building) are distributed over the four 'façades' and the four angles of the church. Clearly the artist intended the relationship between the various elements to be a purely abstract one. We know from the *locus classicus* of medieval craftsmanship, the *Diversarum Artium Schedula* of the presbyter Theophilus, that the architectural cover of the censer was conceived as a representation of the Heavenly Jerusalem, and our censer-cover seems to be an illustration of this. At the same time the architectural form lends itself to a monumental effect.

This striving after order and system is a new element in Romanesque art. The transcendental exuberance of the Ottonian period has calmed down, and in certain respects this actually leads to a reversal of previous stylistic tendencies.

To establish order a clear division between all the component parts is required. We saw that in tenth- and eleventh-century art figures and ornament tended to be fused. This had been a means of transforming the realistic picture inherited from classical times into an abstract pattern. The works of the twelfth century are founded upon this achievement; in fact, the strict geometrical system of Romanesque compositions would be inexplicable without it. But we often find a stricter scheme of squares or medallions (Plates 38, 42), clearly separating figures and ornament and assigning to each its own compartment. Moreover, within that compartment a Romanesque figure has often more freedom than an Ottonian figure had. There the unity of a composition had entirely depended on the figures conforming to the ornamental scheme. Now the figure, firmly held in the square or circle assigned to it and thus removed from all the accident of naturalistic representation, is free to move within these narrow limits. Even with the double barrier of the architectural system and a consistent ornamentalism figures of the twelfth century often surprise us by a humanity which has been absent in many earlier works. The two Holy Women greeting each other in a Visitation scene in a German manuscript (Plate 44) have all the qualities of pure ornament, and they stand like pillars in the centre of a sheet of gold. Nevertheless there is real human pathos in the gentleness of their embrace.

A heavier appearance, more massive proportions, and clearly defined outlines often add to this new form of realism. Most Romanesque figures are much more firmly planted on the soil than their forerunners in the tenth and eleventh centuries,

which often float in the air, or are balanced precariously on the ground line. In spite of their remoteness from nature they are less ethereal. The transcendental world has been made concrete and tangible.

This new realism is particularly striking in those schools of painting and sculpture which in the course of the twelfth century fell under fresh Byzantine influence. Byzantine art, in spite of the conventionalism and the hieratic solemnity which it had adopted, still retained something of the classical conception of the human figure as an independent organism. For example, in an English miniature of about A.D. 1200 (Plate 45), contemporary, it will be remembered, with the entirely ornamental style of the Lewis chessmen, we see a figure of Christ, not only heavy and three-dimensional, but organic in its movements and draped in garments which do not obscure but rather emphasize the structure of the body underneath; the face is softly modelled, well-proportioned, and gentle despite its impersonal gravity. Here we may clearly see Byzantine influence. But still the scheme of the page is so regular, the field occupied by the figure so clearly defined, that there is no danger of the abstract system being upset by the free movements of the human body.

The new realism of Romanesque art, therefore, only exists in virtue of its abstractness. The system of the composition is so clear and flawless, the transformation of the lines of a figure or a scene into ornaments is so complete, that any amount of organic matter can be pressed into this mould. At a moment when the last trace of the slavish imitation of classical models has disappeared, when all the ballast of half-understood naturalistic devices which the Carolingian artists had taken over from their Mediterranean models has been thrown overboard and the ideal of archaic severity has been reached, the medieval artists approach the world afresh, confident in the possession of a

language which is entirely their own and which enables them to assimilate every subject to their own conception. Even now, indeed, there is little actual study of nature. The main sources of the artist, in the twelfth century no less than in all the previous centuries from the end of the classical period, are the works of his forerunners. But he is no longer enslaved by these models to the same extent as was a Carolingian or even an Ottonian painter or sculptor. It is now much more difficult to recognize the traditional types, and new types of figures and compositions are invented. The artist may represent anything he chooses, and he represents it in perfect form.

This new freedom finds its clearest expression in the development of iconography. Twelfth-century art is much richer and more varied in subject-matter than Christian art had ever been before. The motive power behind this expansion is first and foremost a desire to represent Christ and His plan of redemption. Subjects are chosen for their symbolic significance rather than for their intrinsic interest. This leads to a remodelling of traditional iconographical types and to the creation of many new ones. It leads above all towards encyclopædic comprehensiveness, to the establishment of impressive iconographical cycles which are supreme examples of architectural organization in Romanesque art.

The best-known of these is the so-called typological system, which puts together events of the Old and the New Testament in order to show how the one foreshadows the other. This parallelism was a favourite subject of the Fathers of the Church, and found expression sometimes even in Early Christian art, but from Carolingian times onwards it hardly ever plays any part in iconographical schemes, and it is not until the Romanesque period that a full and consistent typological system is worked out. The Early Christian and Carolingian artists had

endeavoured above all to bring to life the individual Bible story. In Romanesque works, however, the story is very often of importance only in so far as it has a bearing on the plan of salvation and can be used as an element in the construction of the doctrinal scheme. The miniature from a Flemish Bible (Plate 43), showing the sin-offering of the Old Testament in close relation to the Crucifixion, of which it was held to be a counterpart, illustrates this method. The relationship receives particular emphasis through the formal device by which the two scenes are enclosed in the same frame and made part of one symmetrical composition. The enamelled cross by Godefroid de Claire (Plate 38) also shows Old Testament scenes which were regarded by medieval thinkers and artists as symbols of the Crucifixion (cf. description of Plate 38, page 110). Most of these had not been represented before the twelfth century.

The systematic elaboration of iconography is, however, not confined to the holy Scriptures. It extends to many other subjects, whether religious or secular, which had previously been either unknown or unimportant in Christian art. We now find the signs of the Zodiac, scenes representing the months, the seven liberal arts, philosophers and poets of the classical age, arranged in series or cycles on the arch of a porch, or in stained glass or in illuminated manuscripts, the reason being that they all have been interpreted symbolically as part of the divine plan for the redemption of man. For the same reason such seemingly secular subjects as animal scenes become very frequent. Plate 47 shows a page from a Bestiary, a medieval textbook of zoology with descriptions and explanations of various animals and their habits, which are fantastic and even childish from the modern scientific point of view, but not to the medieval reader who accepted everything as real which could be related to Christ and the doctrine of the Church (cf. description of

Plate 47, page 114). Secular art hardly exists, or rather the distinction between sacred and profane is immaterial since everything proceeds from Christ.

Thus in the twelfth century the didactic tendency, the desire to impress the spectator with a definite message, which had influenced all artistic activities since the Late Antique period, finds its supreme fulfilment. From the propagandist art of the late Roman emperors, and the symbolic language used in the earliest Christian monuments, the way had led to the vivid narrative style of early Byzantine and Carolingian art, and to the ecstatic expressionism of the Ottonian age. Now, in the twelfth century, religious fervour is rationalized, and presents itself in the form of a strict system which includes the whole world and puts everything into relation with a central idea.

Romanesque art thus combines perfect abstract form with a profound spiritual significance. The two aims of earlier times, to create pure ornamental designs and to convey a definite message, are finally merged into one. Every theme, whether sacred or profane, is subjected to an inflexible transcendental system which is at the same time an entirely harmonious pattern.

The country which more than any other contributed towards the systematic organization of iconography and clear ornamental beauty of style in Romanesque art was France. Having remained in the background during the tenth and eleventh centuries, when so many other countries went through a phase of intense creative activity, she suddenly at the end of the eleventh century assumed the lead and retained it throughout the Romanesque and Gothic periods. In France the Ottonian genius for subtle expressiveness and abstract order, and the robust and primeval archaism of Spanish art were united. It was here that in the last decades of the eleventh and the earlier part of the

twelfth century that amazing development of architecture took place, of which the elaborate organism of the Romanesque cathedral, with its arcades, pilasters and ribbed vaults, is the result. Here, too, monumental sculpture was reborn and became an essential part of the architectural system. But the new evolution did not remain within French frontiers. From France it spread to England, Germany, and Italy. Romanesque art is an international art, the art of Europe in the twelfth century.

There are, it is true, regional differences. Moreover, the pace of the development is not the same in all the countries. France, the originator of the new art, makes rapid strides towards perfection, pressing forward into unknown territory, towards the Gothic style, which is in vigorous growth in the second half of the twelfth century. Germany, on the other hand, lags behind. Her Romanesque art takes on a hybrid and baroque richness, and, unlike France, she does not progress towards Gothic art until the middle of the thirteenth century. Then, too, there are national characteristics, largely due to the different stylistic traditions of the various countries. We may, for instance, discover in English works of the twelfth century, such as the ivory panel from St. Albans (Plate 41B), traces of the diffuse, sketchy and nervously exuberant manner of Winchester ornaments; in other English Romanesque works we find that predilection for grotesque types and exaggerated movements and gestures that had been typical of eleventh-century drawings, as may be seen in many illustrations of the Psalter from St. Swithin's Priory, which contains characters worthy of a Breughel or a Bosch (Plate 46). But on the whole the international features are much more conspicuous than the national.

Even Byzantine art, although belonging to a sphere to which the term Romanesque does not apply, is not entirely

independent of the development in the West. Byzantium, as might be expected, follows its own traditions, and continues to serve as a storehouse of classical style. Even in twelfth-century miniatures we still find narrative scenes executed in what is essentially a late-antique style and technique, with scenery, space, and impressionistic lights giving shape to folds, faces and mountain crags (Plate 37). Byzantine art never undergoes the revolutionary changes of Western early medieval art; it lacks the fermenting process by which the taste for abstraction and ornament led to a complete transformation of classical models. This continued adherence to traditional types and traditional techniques always distinguishes Byzantium from the West, and the development in the centuries following the Macedonian Renaissance largely consists in a stereotyping of the traditional style. But it is difficult to distinguish between this inherent sterility and a positive tendency towards hieratic representation, which, ever present in Byzantium, had become conspicuous in the works of the tenth and eleventh centuries. This tendency we have found to be a bond between Eastern and Western art of the period, and as it increases in the twelfth century, Byzantine works acquire in their own way a monumental austerity and archaic simplicity comparable with that of Western Romanesque art (page 97). Expressed in such general terms, this may seem to indicate no more than a vague and perhaps accidental parallelism; but the connexion becomes more definite when we consider that at that period the paintings and mosaics of churches in the Byzantine sphere of influence show an increasingly monumental composition and systematic arrangement in conformity with the architecture. They must, like Western Romanesque paintings and sculptures, be regarded more and more as part of the architectural organism. When we find in Byzantine manuscripts of the twelfth century narrative scenes no longer occupying a page of their own, but

inserted into an elaborate ornament at the beginning of a chapter, a practice quite unknown in the earlier periods, we cannot help recalling the very similar principles evolved at that time in the West (compare Plate 37 with Plate 42). While the hieratic tendencies of the tenth and eleventh centuries seem to have been, at least to some extent, imported from Byzantium to the West, this systematic organization of figures and ornament is more probably a sign of Western Romanesque taste making at least a faint impression on the contemporary art of the East.

But this does not affect the essential character of Byzantine art. It remains independent, whereas the Western countries have a stylistic unity based on a common foundation.

The unity of Romanesque art in the West springs from profound historical causes. The styles of the tenth and eleventh centuries were the result of spontaneous efforts of rulers and monasteries in individual countries. Behind the art of the twelfth century stands the Church universal at the height of her power. It is the period in which the long-continued strife of the popes for supremacy over the German emperors ended in victory. It is also the period in which the inner strength of the Church reached its highest level, an age of fundamental and drastic reforms promoted by the great monastic orders of France. Thence the religious ideal spread all over Europe. Emperors, kings, and knights from.all countries united in the cause of Christ and embarked on the great adventure of the Crusades.

Such is the background against which Romanesque art must be viewed, and the foundation of its international character. It is the foundation, too, of its iconography and style. The comprehensive and encyclopædic character of Romanesque imagery, its elaborate iconographic system and the formal arrangement

of the compositions, the feeling of calm dignity and absolute finality which it creates, are all the expression of a profound desire to represent the world as subordinated to the supreme and eternal power of Christ and the Church which represents Him. The artist aims at a subordination of the material world to a spiritual and transcendental order of which the Church is the centre and the guardian. He is doing in art what contemporary scholastic philosophy, then approaching its zenith, is doing in words.

Romanesque art represents the fulfilment of the task undertaken by artists when, at the end of the classical period, they began to lose touch with reality and broke up the harmonies created by the Greeks, in order to give expression to new creeds such as the cult of the emperor and the Christian religion.

A long and arduous path had to be trodden before the new transcendental tendencies, which at first seemed almost entirely negative and merely a symptom of decadence, had assumed stylistic forms which are a complete and positive expression of a new conception of the world. The decisive moment came when in the Carolingian age the Mediterranean heritage was taken over by the peoples of the North, whose tradition of wholly abstract and ornamental art enabled them to give visible form to purely transcendental relationships. By applying in the following centuries the principles of this art to the descriptive paintings and sculptures taken over from the South, a perfect subordination of matter to abstract harmony was effected, and that is the essence of Romanesque art.

Thus during the early Middle Ages, which are still too often regarded merely as a hiatus, the entire foundations of European art were changed, and a new and great ideal found full expression. Romanesque art does not represent a beginning but a final synthesis. While Gothic art continued along these lines a

romantic flavour and a mysticism of an individual kind soon began to appear (Plate 48), which though they even tended to emphasize the transcendental character of medieval style, also contained the germ that was eventually to destroy its austere and impersonal greatness.

DESCRIPTION OF THE PLATES

★

[Unless otherwise indicated, 'right' and 'left' mean the right and left of the spectator.]

Pl. 1. SEPULCHRAL BUST FROM PALMYRA

A bearded man ('Hairan, son of Marion') wearing a toga. Limestone.

Height: 25 in. From Palmyra (Syria). Second century.

Department of Egyptian and Assyrian Antiquities, No. 125032.

Pl. 2. TOMBSTONE FOUND NEAR CARTHAGE

In the upper zone Castor and Pollux (?) with their horses on either side of a deity; below, two men sacrificing, a man leading a bull, another man following him with a basket, and three figures praying.

Height: *ca.* 36 in. Probably second century.

Department of Egyptian and Assyrian Antiquities, No. 125345

Pl. 3. JEWISH STONE CIST (OSSUARY), FROM PALESTINE

A coffin-shaped box with a coped lid, covered with conventional ornament.

Length: 32·6 in. Probably first century.

Department of Egyptian and Assyrian Antiquities, No. 126392

Pl. 4. MUMMY WITH PAINTED MASK, FROM EGYPT

Mummy-case of a young man ('Artemidoros') with portrait-bust painted on a wooden panel.

Height: 66 in. From the Fayyum. Second century.

Department of Egyptian and Assyrian Antiquities, No. 21810
Handbook to the Egyptian Mummies and Coffins, p. 13 and Pl. VI.

Pl. 5. GILDED GLASSES FROM THE ROMAN CATACOMBS

(A) Bottom of a drinking-vessel with design applied in gold foil, showing busts of bride and bridegroom, and Our Lord holding a wreath over each head. Inscribed: DULCIS ANIMA VIVAS (Live, sweet soul).

Diameter: 2·2 in. Fourth century.

Department of British and Medieval Antiquities.
Catalogue of Early Christian Antiquities, No. 613.

(B) Bottom of a similar vessel with busts of bride and bridegroom, and Cupid laying his hands on their heads. Inscribed: . . . NE TZUCINUS BIBITE (. . . (and) Tzucinus, drink).

Diameter: 3·8 in. Fourth century.

Department of British and Medieval Antiquities.
Catalogue of Early Christian Antiquities, No. 612.

Pl. 6. IVORY PANEL WITH THE APOTHEOSIS OF AN EMPEROR

Below, a funeral car drawn by four elephants, with the figure of the emperor seated under a canopy. In the background the deified emperor (?) rising from the pyre in a *quadriga* with two eagles accompanying him. Above, the emperor carried to heaven by two winged genii, with five men watching from a cloud. To the right a bust of the sun-god behind a section of the Zodiac. On the frame a monogram, perhaps standing for SYMMACHORUM.

Height: 11·9 in. Probably Italian. Late fourth century.

Department of British and Medieval Antiquities.
Catalogue of Ivory Carvings, No. 1.

Pl. 7. TWO PANELS OF AN IVORY CASKET WITH SCENES FROM THE PASSION

(A) The Crucifixion with the soldier (Longinus) piercing Our Lord's left side, the Virgin and St. John standing to His right. On the left, Judas hanging from a tree; under his feet the purse with the thirty pieces of silver.

(B) The two Marys at the Sepulchre, with two sleeping soldiers seated on either side of the monument; the doors of the tomb are open, revealing part of the coffin.

Length of panels: 3·9 in. Probably Italian. Early fifth century.

Department of British and Medieval Antiquities.
Catalogue of Early Christian Antiquities, No. 291.

Pl. 8. IVORY LEAF OF A DIPTYCH, WITH FIGURE OF AN ARCHANGEL

The angel stands on a flight of steps underneath an arcade, holding an orb and a sceptre. Above, an inscription in Greek, 'Receive these gifts and having learned the cause. . . .'

Height: 16·2 in. Eastern Mediterranean. Sixth century.

Department of British and Medieval Antiquities.
Catalogue of Early Christian Antiquities, No. 295.

Pl. 9. IVORY PANEL WITH THE ADORATION OF THE MAGI AND THE NATIVITY

Above, to the right, two Magi offering gifts with veiled hands to the Virgin (centre); to the left another, and an angel with cruciform staff. Below, the Virgin reclining on a couch, and the Child in a manger, with the Star of Bethlehem above and the ox and ass on either side; in front the incredulous midwife stretching out her withered hand towards the Child.

Height: 8·5 in. Eastern Mediterranean (?Palestine). Sixth century.

Department of British and Medieval Antiquities.
Catalogue of Ivory Carvings, No. 14.

Pl. 10. SILVER CASKET OF PROJECTA, FROM THE ESQUILINE HILL, ROME

The owner is shown as a bride sitting under an arcade with two servants attending at her toilet; on the remaining sides are others carrying various objects. On the lid Venus seated on a shell and dressing her hair, with two Tritons assisting. The short sides of the lid show Nereids and sea monsters, and on its back there is a

H

representation of the bride being conducted to the bridegroom's house. On the top of the lid are portraits of the bride and bridegroom, and on the front is the following inscription: SECUNDE ET PROJECTA VIVATIS IN CHRISTO (Secundus and Projecta live in Christ).

Silver, partly gilt. Length: 21·7 in. Height: 11 in. Part of a large treasure found on the Esquiline Hill, Rome. Late fourth century.

Department of British and Medieval Antiquities.
Catalogue of Early Christian Antiquities, No. 304.

Pl. 11. SILVER BOWL WITH FIGURE OF A SAINT, FOUND IN CYPRUS

In the centre of the bowl a bust of a saint (St. Sergius or St. Bacchus) carrying a cross and surrounded by an ornamental border in niello. The rim is chased with a foliate frieze. On the back of the bowl are five Byzantine control-stamps, including two with cruciform monograms and one circular stamp, with a bust of a bearded emperor without a nimbus (Phokas?).

Diameter: 9·4 in. Height 2·8 in. From Kerynia, Cyprus. About A.D. 600.

Department of British and Medieval Antiquities.
Catalogue of Early Christian Antiquities, No. 398.

Pl. 12. FRAGMENTS OF LEAVES FROM AN ILLUSTRATED GREEK BIBLE ('COTTON GENESIS')

(A) Illustration of Gen. xvi, 5 ff. Sarah. 5·8 in. × 2·5 in.
(B) Illustration of Gen. xix, 11. Lot (to the left) defends his house against the Sodomites. 4·3 in. × 3·7 in.

Probably from Egypt. Fifth century.

Fragments of Cotton MS. Otho B. VI, on loan from the Baptist College, Bristol.

Pl. 13. LEAF OF A GREEK GOSPEL-BOOK

Part of the Eusebian canon-tables in a setting of ornamental arcades. Beneath the arches medallions with busts, perhaps representing apostles.

8·5 in. × 6·1 in. Said to have belonged to one of the monasteries on Mount Athos; originally, perhaps, from Asia Minor. Seventh century.

Add. MS. 5111. f. 11.

Pl. 14. SILK PANEL WITH TWO HORSEMEN, FOUND IN EGYPT

Two figures of mounted huntsmen with lions and dogs, in a medallion.

Ca. 9·5 in. × 8·6 in. Sixth to seventh century.

Department of Egyptian and Assyrian Antiquities.
Guide to the fourth, fifth and sixth Egyptian Rooms and the Coptic Room, No. 17173.

Pl. 15. COPTIC TOMBSTONE

Below, a bird with a cross in its beak standing on a branch; between its wings a medallion with a cross. Above, a cross between two columns, and an inscription in Greek commemorating Sophrone.

Height: 32 in. From Egypt. Seventh century.

Department of Egyptian and Assyrian Antiquities, No. 1790.
Catalogue of Early Christian Antiquities, No. 942.

Pls. 16, 17. TWO PAGES FROM THE LINDISFARNE GOSPELS

Pl. 16 shows the opening page of the Gospel of St. Mark with an ornamental composition; Pl. 17 a portrait of St. John sitting on a stool and holding a scroll in his hand. Above his head the symbolic eagle, holding a book.

13·5 in. × 9·7 in. According to a tenth-century note these Gospels were written by Eadfrith, Bishop of Lindisfarne (698–721).

Cotton MS. Nero D. IV. ff. 94b, 209b.

Pls. 18, 19. TWO PAGES FROM A CAROLINGIAN GOSPEL-BOOK

Pl. 18 shows St. Matthew sitting on a chair and writing his Gospel; behind him in an elaborately framed niche the symbolic angel;

Pl. 19 shows the opening words of the Gospel of St. Luke in an ornamental setting; enclosed in the letter Q are busts of the Virgin and St. Elisabeth, and the Angel appearing to Zacharias.

14·6 in. × 10 in. 'Ada Group'. Lower Rhine. Ninth century.

Harley MS. 2788. ff. 13b, 109.

Pl. 20. MOSES RECEIVING THE LAW AND ADDRESSING THE ISRAELITES: FROM A CAROLINGIAN BIBLE

In the upper panel Moses on Mount Sinai surrounded by flames, receiving the Law from the hand of God, which is stretched out from heaven; on the left Joshua. In the lower panel Moses in a hall teaching the Law to the Israelites, led by Aaron; to the left Joshua holding up a curtain.

19·9 in. × 14·7 in. School of Tours. Ninth century.

In the late sixteenth century the MS. belonged to the Monastery Moûtiers-Grandval near Basle.

Add. MS. 10546. f. 25b.

Pl. 21. OPENING PAGE OF ST. LUKE, FROM A CAROLINGIAN GOSPEL-BOOK

The page contains the first two words of the Gospel (*Quoniam quidem*) in an ornamental frame. The 'Q' forms a large initial with interlace and animal ornament.

11 in. × 7·2 in. 'Franco-Saxon group.' Probably written in Eastern France or Belgium. Ninth century.

Egerton MS. 768. f. 2.

Pl. 22. LEAF OF AN IVORY DIPTYCH WITH SCENES FROM THE CHILDHOOD OF CHRIST. CAROLINGIAN

On top the Annunciation, with the Virgin seated on a cushioned chair and the Angel approaching from the left. In the middle the Nativity, with the Virgin lying on a mattress within a walled enclosure, while Joseph is seated outside; in the background the manger with the ox and the ass. Below, the Adoration of the Magi with the Virgin seated on a chair to the left and the three Magi

approaching from the right guided by the Star of Bethlehem. Many figures retain traces of colouring, chiefly red, blue and gold.

Height: 6·5 in. 'Ada Group.' Lower Rhine. Ninth Century.

Department of British and Medieval Antiquities.
Catalogue of Ivory Carvings, No. 42.

Pl. 23. LEAF OF AN IVORY DIPTYCH WITH SCENES FROM THE LIFE OF CHRIST. CAROLINGIAN

Above, the Transfiguration; Our Lord in a mandorla flanked by Moses and Elias, while SS. Peter, James and John prostrate themselves before Him. Below, the Entry into Jerusalem; Our Lord riding on a mule accompanied by some of His disciples; to the right two men spreading their garments on the way, and in the background men holding palm-branches.

Height: 6·4 in. School of Metz. Tenth century.

Department of British and Medieval Antiquities.
Catalogue of Ivory Carvings, No. 46b.

Pl. 24. IVORY PANEL WITH THE MIRACLE AT CANA. CAROLINGIAN

Above, to the left, Our Lord with three companions conversing with the Virgin, while to the right two servants wait on three guests feasting at a table. Below, Our Lord in conversation with the master of the house, and two servants carrying vases of water; in the foreground a row of six jars.

Height: 5·6 in. 'Liuthard Group.' Ninth century.

Department of British and Medieval Antiquities.
Catalogue of Ivory Carvings, No. 44.

Pl. 25. ROCK-CRYSTAL ENGRAVED WITH THE STORY OF SUSANNA AND THE TWO ELDERS (THE CRYSTAL OF LOTHAR). CAROLINGIAN

On top Susanna (SCA SUSANNA), in an enclosed garden, carrying two vessels for unguents, and the two elders who 'rose up and ran unto her' (SURREXERUNT SENES), while to the right two servants come to her aid (ACCURRERUNT SERVI). Below, to the right, the two elders in the house of Joacim ordering the servants to bring

Susanna before them (MITTITE AD SUSANNAM), and, again below, the two elders extending their hands over Susanna's head (MISERUNT MANUS) in the presence of the people. At the bottom of the disk, to the right, an official leading Susanna away to put her to death (CUMQUE DUCERETUR AD MORTEM) and Daniel encountering them, while two figures to the right and left express astonishment. To the left of this group Daniel, rebuking one of the elders for being 'waxen old in wickedness' (INVETERATE DIERUM MALORUM) and two figures expressing approval. Above, on the left, Daniel convicting the other elder of falsehood (RECTE MENTITUS ES) and three figures expressing indignation. Over this scene the stoning of the elders (FECERUNTQUE EIS SICUT MALE EGERANT). In the central medallion Susanna with two companion figures standing before Daniel, who is seated as a judge under a canopy. The legend is the following: ET SALVATUS EST SANGUIS INNOXIUS IN DIE ILLA ('Thus the innocent blood was saved the same day'). Round the top of the medallion the legend: LOTHARIUS REX FRANCORUM FIERI IUSSIT (Lothar King of the Franks ordered this to be made).

Diameter: 4·5 in. The Lothar here mentioned must either be the emperor (843–855) or his son of the same name (855–869).
Probably made in N.E. France. From the tenth century until the French Revolution the crystal was in the Abbey of Waulsort on the Meuse.
Department of British and Medieval Antiquities.
Catalogue of the Engraved Gems of the Post-Classical Periods, No. 559.

Pl. 26. IVORY PANEL WITH THE RAISING OF THE WIDOW'S SON

Our Lord followed by a group of apostles, touches with His hand the body of the dead man, who is carried out of the gate of the city on a bier, accompanied by the weeping mother and another mourner.

Height: 4·9 in. From Milan or Reichenau. About 970.
Department of British and Medieval Antiquities.
Catalogue of Ivory Carvings, No. 55.

Pl. 27. THE ANNUNCIATION, FROM A GERMAN GOSPEL-BOOK

The figures are enclosed in a city conventionally represented.
From the monastery of Echternach, near Treves. Early eleventh century.

Harley MS. 2821. f. 22b.

Pl. 28. PORTRAIT OF ST. LUKE, FROM AN ENGLISH GOSPEL-BOOK ('THE GRIMBALD GOSPELS').

The evangelist is seated on a chair with a writing desk by his side, while the symbolic ox dictates the gospel.

12 in. × 9 in. Winchester School. Early eleventh century.

Add. MS. 34890. f. 73b.

Pl. 29. (A) ILLUSTRATION OF PSALM CIV FROM AN ENGLISH PSALTER

Above, Our Lord accompanied by the angels, His 'ministers', 'walking upon the wings of the winds', which are represented as human heads blowing upon the earth. To the right and left are sun, moon and stars ('He appointeth the moon for the seasons; the sun knoweth his going down'). Below are shown the Lord's creations. To the left, among 'mountains', 'valleys', and 'springs', is 'every beast of the field', the 'fowls of the heaven . . . which sing among the branches', and the 'birds' which 'make their nests on the Cedars of Lebanon'. A ploughman symbolizes man who 'goeth forth to his work and to his labour', while three men seated at a table and served by two attendants with wine and oil represent the 'wine that maketh glad the heart of man' and the 'oil to make his face shine'. In front of this scene is the 'great and wide sea'; 'Here go the ships; there is that Leviathan'. To the right the 'young lions roar after their prey'. Above them the 'high hills which are a refuge for the wild goats', and the Psalmist raising his right hand towards the Lord and pointing to the Creation with his left.

Width of page: 12·4 in. Probably from St. Augustine's Abbey, Canterbury. About A.D. 1000.

Harley MS. 603. f. 51b.

(B) St. Pachomius Receiving the Easter Tables, from an English Manuscript

Pen-drawing illustrating a collection of tables and tracts for finding Easter. St. Pachomius with three of his monks prostrate themselves before an angel from whom they receive the Easter Tables. To the right a church.

Width of page 6·7 in. Probably from Christ Church, Canterbury. Shortly before A.D. 1058.

Cotton MS. Caligula A.XV. f. 122b.

Pl. 30. Adam and Eve, from an Italian Exultet Roll

To the left, the Tree of Knowledge with the serpent coiled round it, the tail round the foot of Eve, who takes the apple in her right hand and puts it in the mouth of Adam with her left. To the right, the Tree of Life.

Height of figures *ca.* 5·2 in. From Montecassino. Second half of eleventh century.

Add MS. 30337.

Pl. 31. The Four Horsemen of the Apocalypse, from a Manuscript of Beatus' Commentary on the Apocalypse

See Revelation vi. 2 ff. 14 in. × 9·5 in. Written for the Abbey of San Domingo de Silos (Spain). Between A.D. 1091 and 1109.

Add. MS. 11695. f. 102b.

Pl. 32. Ivory Triptych with the Crucifixion and Saints

In the centre Our Lord on the Cross, with the Virgin and St. John, and half figures of the Archangels Michael and Gabriel. On the wings, left: St. Cyrus, St. George, St. Theodore, St. Menas, St. Procopius; right: St. John, St. Eustathius, St. Clement of Ancyra, St. Stephen, St. Cyrion.

Height: 10·8 in. Byzantine. Tenth century.

Department of British and Medieval Antiquities.

Pl. 33. Ivory Panel with the Nativity

In the centre the Virgin reclining on a mattress; behind her the Child in a manger of masonry with the heads of the ox and the ass above. To the left a group of acclaiming angels and to the right an angel announcing the birth of Christ to the shepherds. In the foreground Joseph, seated, and a midwife bathing the Child in a two-handled vessel beside which stands a ewer.

Height: 4·6 in. Byzantine. Tenth century.

Department of British and Medieval Antiquities.
Catalogue of Early Christian Antiquities, No. 300.

Pl. 34. Marble Slab with Allegorical Representations of Animals

In the centre an eagle grasping a serpent. To the right and left almost symmetrical groups of eagles grasping hares.

Length: 95 in. Byzantine. Tenth to eleventh century.

Department of British and Medieval Antiquities.

Pl. 35. The Manna and the Quails, from a Byzantine Psalter

Above, to the right, two Israelites collecting in baskets the manna falling from heaven (represented by a section of a globe). Below, a flight of quails moving towards the left, where an Israelite is seen roasting quails on an open fire, while another stands opposite him plucking one of the birds.

Illustration of Psalm lxxviii. 24 ff.

4·5 in. × 3·6 in. Eleventh century.

Add. MS. 40731. f. 128.

Pl. 36. Portrait of St. Luke, from a Byzantine Gospel-Book

The evangelist seated at a desk and composing his Gospel. Behind him an arch from which a lamp is suspended.

Size of panel: 6·7 in. × 5 in. Tenth century.

Add. MS. 28815. f. 76b.

Pl. 37. THE MARTYRDOM OF ST. ANTHIMUS, FROM A MANUSCRIPT OF SIMEON METAPHRASTES' LIVES OF SAINTS

Headpiece of the Life of St. Anthimus, with a portrait of the Saint and four scenes from his martyrdom. Above, to the left, the Emperor Maximian seated on a throne and sending out messengers to take St. Anthimus prisoner. To the right the messengers on horseback finding the saint in his retreat. Below, to the left, the saint tortured on a wheel in the presence of the Emperor. To the right the saint's last prayer and his execution.

Height of miniature: 7 in. Byzantine. Eleventh to twelfth century. Add. MS. 11870. f. 44b.

Pl. 38. ENAMELLED CROSS WITH OLD TESTAMENT SCENES, BY GODEFROID DE CLAIRE

Cross made of copper, with ornament in champlevé enamel and semi-precious stones, and with figure-scenes in enamel at the end of each arm and in the centre. On top the Brazen Serpent supported by a pole (a symbol of the Crucified Christ) with Moses and Aaron standing on either side (Num. xxi, 8). To the left Elijah visiting the Widow of Zarephath, who has been collecting sticks (a symbol of the Cross; 1 Kings xvii, 8). Below, Joshua and Caleb carrying, on a staff, the grapes from the Promised Land (a symbol of Christ on the Cross; Num. xiii, 23). On the right an Israelite in Egypt writing the letter Tau (a symbol of the Cross) on the door of his house (Exod. xii, 7). In the centre Jacob blessing Ephraim and Manasseh with crossed hands, the right hand on the head of Ephraim (Gen. xlviii, 12–15); this was interpreted as showing his preference for the younger grandson, a symbol of the New Covenant, as represented by the Crucifixion, replacing the Old.

Height: *ca.* 14·5 in. Made by Godefroid de Claire, a native of Huy, who worked in the Meuse region in the third quarter of the twelfth century.

Department of British and Medieval Antiquities.
Guide to Medieval Antiquities, fig. 44.

Pl. 39. BRONZE COVER OF A CENSER
The cover has the shape of a building with four equal arms sur-
mounted by turrets, and a central tower. At the ends of the four
arms are half-figures of angels enclosed in foliate scrolls. In the
angles between the arms the symbols of the four evangelists. The
four arms are joined at the bottom by four half-figures of lions.

Height: 5·1 in. Lower Rhine or Meuse region (?). Late twelfth
century.

Department of British and Medieval Antiquities.
Guide to Medieval Antiquities, fig. 23.

Pl. 40. STONE CAPITAL WITH THE MIRACULOUS DRAUGHT
OF FISHES, FROM LEWES PRIORY
Two apostles in a boat holding a net, one also holding an oar.

Height: 10 in. From Lewes Priory, Sussex. Twelfth century.

Department of British and Medieval Antiquities.

Pl. 41. (A) IVORY CHESSMEN FROM THE ISLAND OF LEWIS
A king, with a floriated crown, sitting on a chair, holding a
sword across his knees; a queen with a similar crown, also sitting
on a chair and with a horn in her left hand, while the right is
placed against her cheek; and a bishop, with mitre and chasuble,
sitting on a chair with a crozier in his left hand, his right raised in
benediction.

Height of the king: 4 in. Part of a large collection of chessmen
found on the Island of Lewis in the Hebrides. English or Scan-
dinavian. Twelfth century.

Department of British and Medieval Antiquities.
Catalogue of Ivory Carvings, Nos. 79, 84, 90.

(B) FRAGMENT OF IVORY PANEL WITH MALE FIGURE
IN FOLIATE SCROLL

Openwork design, showing a man in a short tunic standing in a
floral scroll and grasping the stem with both hands. Below, a
beaded border.

2·3 in. × 2·3 in. Found at St. Albans. English. Twelfth century.

Department of British and Medieval Antiquities.

Pl. 42. Illustration of the First Chapter of Genesis, from a German Bible

A large ornamental panel containing the first two words of the chapter (IN PRINCIPIO). The whole length of the panel is occupied by the letter I, which consists of a long shaft filled with interlace, and figure-medallions above and below. The upper medallion shows the Creation of Light, with Christ as the Creator giving the command to three angels, the lower the creation of Eve, with Adam lying asleep and Eve rising from his side at the command of Christ, who stands to the left. Half-way down the shaft of the I a large N is interlaced with it, while the remaining letters are distributed on either side, above and below. The intervals between the letters and the frame of the panel are filled with floral scrolls issuing from the letters I and N.

Size of page: 21 in. × 14·4 in. In the seventeenth century the manuscript was in the church of St. Mary, Worms. A.D. 1148(?). Harley MS. 2803. f. 6b.

Pl. 43. The Crucifixion and Sacrifice of a Calf, from the Floreffe Bible

Headpiece of the Gospel of St. Luke, with figure scenes in two compartments. Above, the Crucifixion with two soldiers on either side of Our Lord; on the left Longinus piercing His side with his spear, on the right Stephaton holding up the sponge filled with vinegar. Below, corresponding to the figure of Christ, a priest (Aaron?) slaying a calf on an altar. Christ's sacrifice is thus related to the slaying of the calf, the sin-offering of the Old Testament (see, e.g., Lev. ix). This is explained by the verses inscribed on the arch:

Pro nevo fraudis vitulus datur hostia laudis
Quod Christus vitulus sit docet hic titulus.

(As a recompense for the blemish of the fraud [i.e. the original sin] a calf is given as a praise offering. That Christ is the calf this title-picture shows.)

The idea is emphasized by the addition of Old and New Testament witnesses holding in their hands scrolls with quotations from their respective books, all referring to sacrifices. Above, St. Paul with a quotation from the Epistle to the Hebrews (ix, 12) and David, with a quotation (Psalm cx, 4). Below, David with a quotation (Psalm xxix, 31) and St. Luke, carrying his symbol, with a quotation from his Gospel (xv, 22f).

Height of miniature: 11 in. Written in the Abbey of Floreffe on the Meuse. About A.D. 1160.

Add. MS. 17738. f. 187.

Pl. 44. THE VISITATION, PROBABLY FROM A GERMAN PSALTER

The Virgin and St. Elisabeth are shown on a gold ground with incised scroll-ornament.

8·7 in. × 5·5 in. Twelfth century.

Cotton MS. Caligula A. VII. f. 4b.

Pl. 45. CHRIST IN MAJESTY, FROM AN ENGLISH PSALTER

Christ seated on a rainbow in a mandorla, holding a book in His left hand, while His right is raised in benediction. Round Him the symbols of the four evangelists.

9 in. × 6·2 in. Written for Westminster Abbey. About A.D. 1200.

Royal MS. 2 A. XXII. f. 14.

Pl. 46. PASSION SCENES FROM AN ENGLISH PSALTER

Above, the Betrayal; a soldier carrying a club and grasping the hand of Christ, while Judas embraces Him; on either side men with grotesque faces carrying various weapons; in the background St. Peter cutting off the ear of Malchus. Below, the Flagellation; to the left Pilate, wearing a crown, is seated on a throne, the Devil, in the shape of a black beast, whispering in his ear.

12·7 in. × 9 in. Written for St. Swithin's Priory, Winchester. About the middle of the twelfth century.

Cotton MS. Nero C. IV. f. 21.

Pl. 47. Page from an English Bestiary

On the top an ibex falling down a cliff, and three huntsmen, one carrying an axe, another blowing a horn, the third aiming at the animal with bow and arrow. Below, a hyena devouring the corpse of a woman, which he has dragged forth from a stone coffin.

The moral interpretation given to their subjects by the writers of the bestiaries may be illustrated by a translation of the text on this page: 'There is an animal called the ibex which has two horns of such strength that if he were cast down from the top of a mountain to the depths his whole body would be supported by them. He signifies, indeed, the learned men, who are wont to hold at bay their ill fortune through the agreement of the two Testaments, as if by a certain inherent strength of their nature, and, as if sustained by the two horns, they support their good deeds by the testimony of the Old Testament and the Gospel lesson.'

Height: *ca.* 12·3 in. Late twelfth century.

Harley MS. 4751. f. 10.

Pl. 48. St. Cuthbert on a Sea Voyage, from a Life of St. Cuthbert

The Saint and his companions sailing back from the island of the Picts.

5·4 in. × 3·9 in. Probably written at Durham. Early thirteenth century.

Add. MS. 39943. f. 26.

THE PLATES

THE PLATES

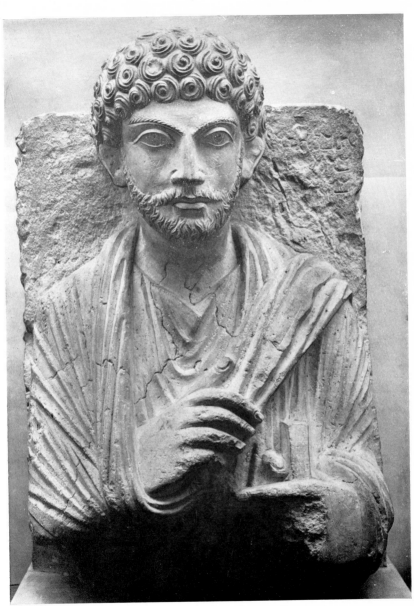

Plate 1. Sepulchral bust from Palmyra
Second century

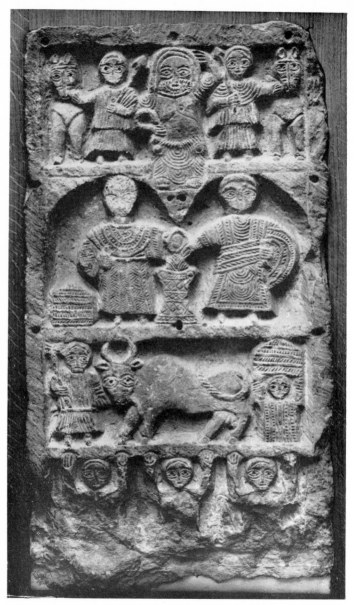

Plate 2. Tombstone found near Carthage
Probably second century

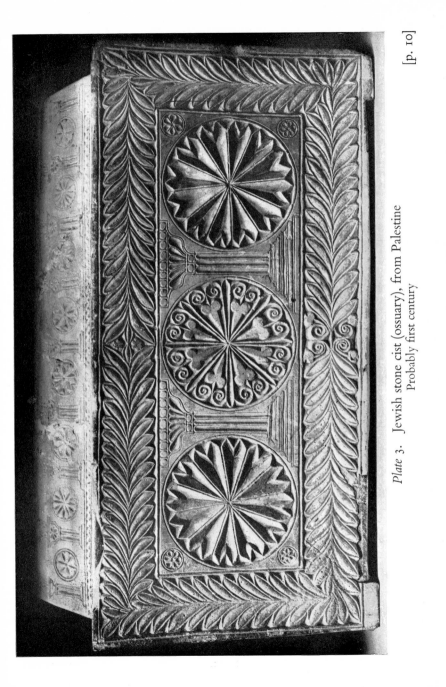

Plate 3. Jewish stone cist (ossuary), from Palestine
Probably first century

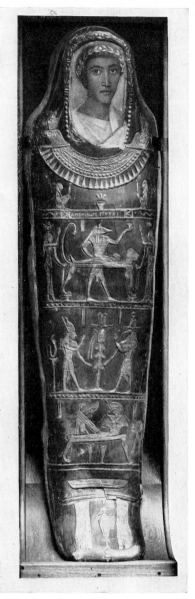

Plate 4. Mummy with painted mask,
from Egypt
Second century [p. 8]

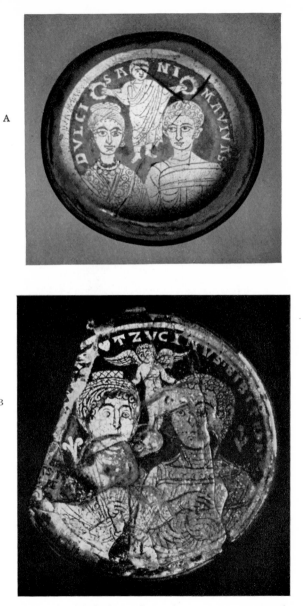

A

B

Plate 5. Gilded glasses from the Roman Catacombs
Fourth century

[pp. 4, 5]

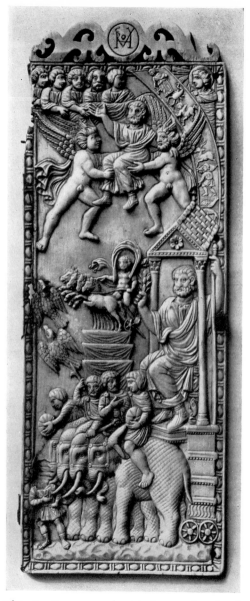

Plate 6. Ivory panel with the apotheosis of
an Emperor
Late fourth century [p. 13]

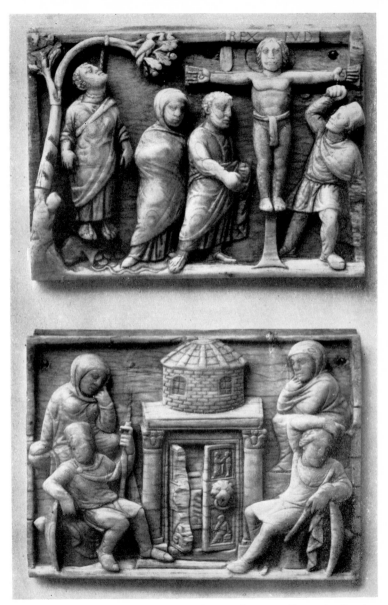

Plate 7. Two panels of an ivory casket with scenes from the Passion
Early fifth century

[p. 21]

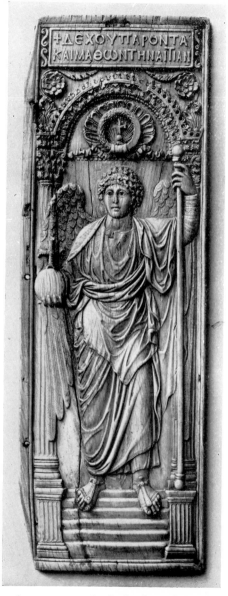

Plate 8. Ivory leaf of a diptych, with
figure of an archangel
Sixth century [p. 23]

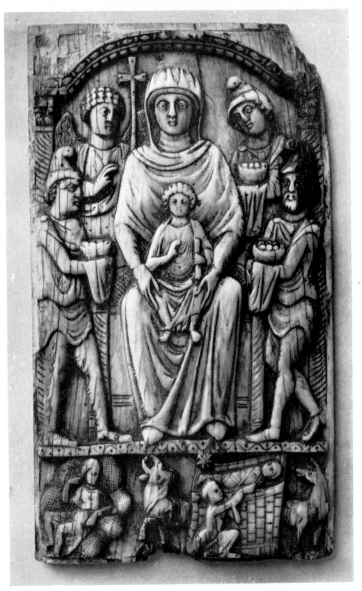

Plate 9. Ivory panel with the Adoration of the Magi
and the Nativity
Sixth century

[p. 27]

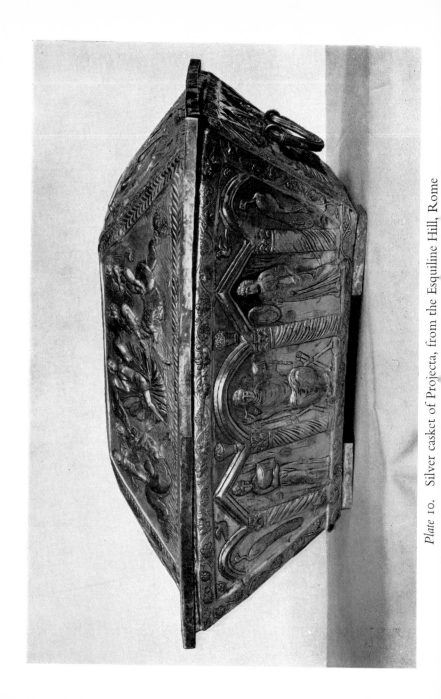

Plate 10. Silver casket of Projecta, from the Esquiline Hill, Rome

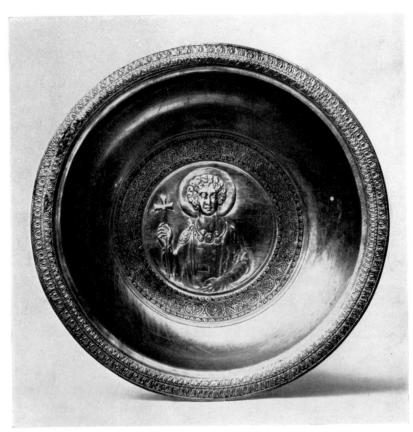

Plate 11. Silver bowl with figure of a Saint, found in Cyprus
About A.D. 600

[p. 25]

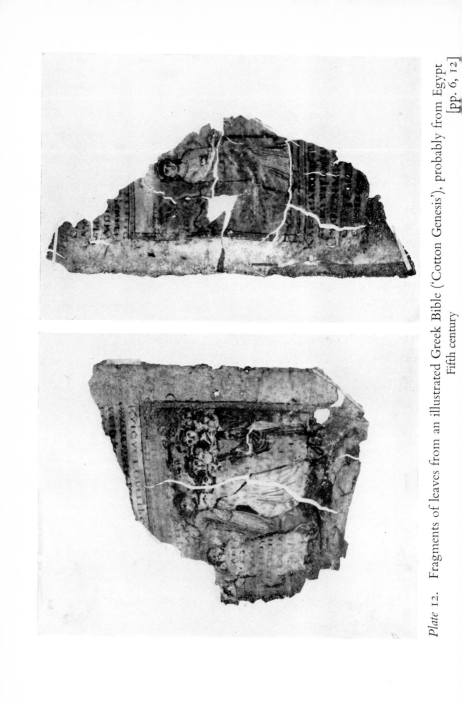

Plate 12. Fragments of leaves from an illustrated Greek Bible ('Cotton Genesis'), probably from Egypt

Fifth century

[pp. 6, 12]

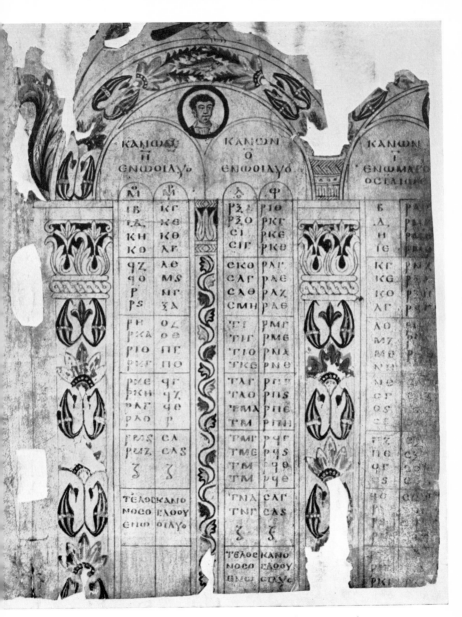

Plate 13. Leaf of a Greek Gospel-book (Add. MS. 5111)
Seventh century

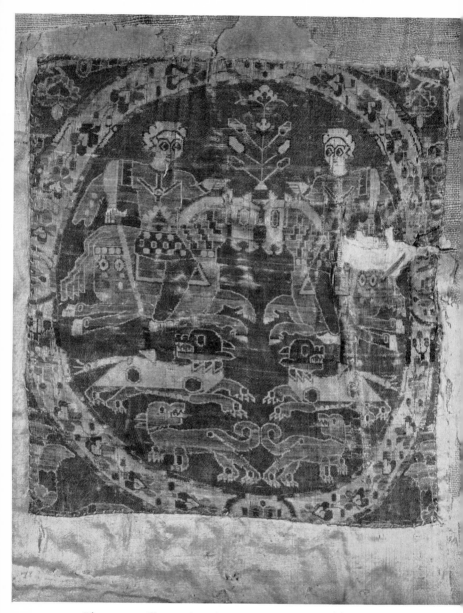

Plate 14. Silk panel with two horsemen, found in Egypt
Sixth to seventh century

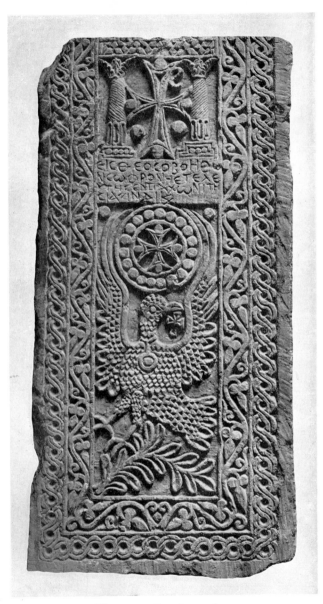

Plate 15. Coptic tombstone
Seventh century [p. 32]

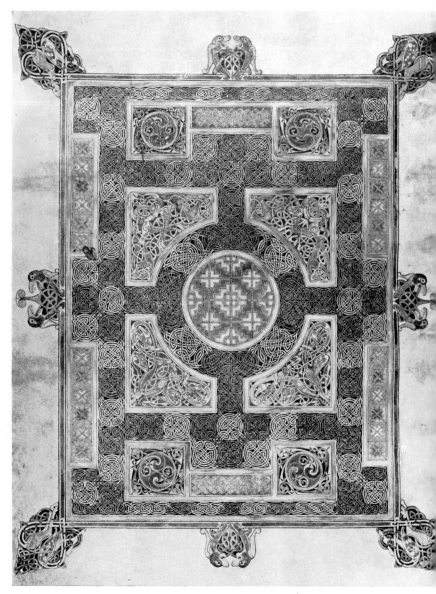

Plate 16. Ornamental page from the Lindisfarne Gospels
About A.D. 700

[p. 38

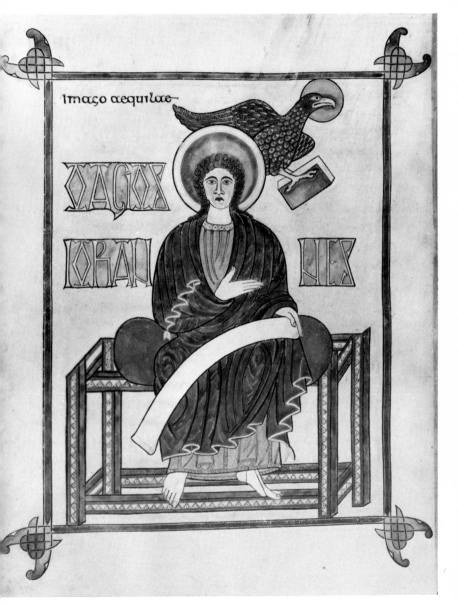

Imago aequilae

Plate 17. Portrait of St. John from the Lindisfarne Gospels
About A.D. 700

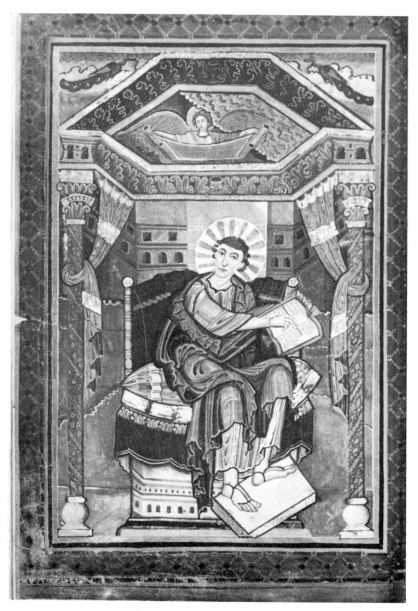

Plate 18. Portrait of St. Matthew from a Carolingian Gospel-book
(Harley MS. 2788)
Ninth century

[p. 46]

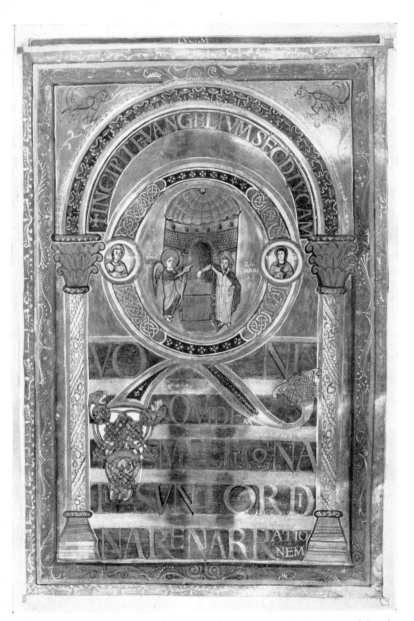

Plate 19. Opening page of St. Luke from a Carolingian Gospel-book
(Harley MS. 2788)
Ninth century [p. 50]

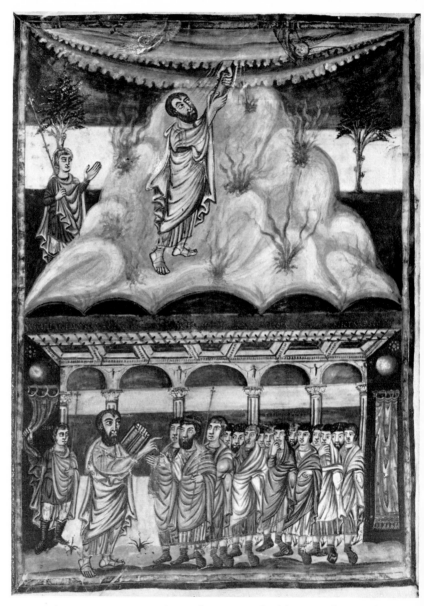

Plate 20. Moses receiving the Law and addressing the Israelites: from a Carolingian Bible (Add. MS. 10546)
Ninth century

[p. 47

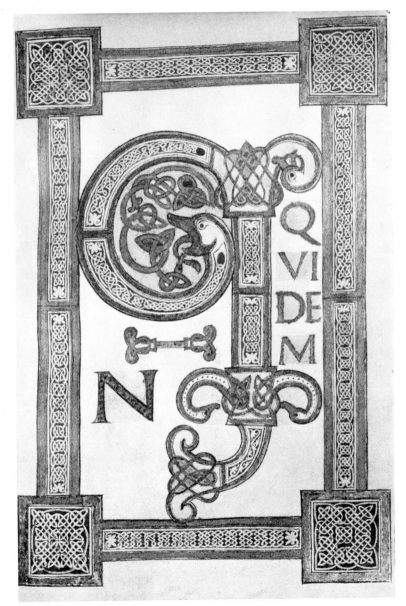

Plate 21. Opening page of St. Luke, from a Carolingian Gospel-book
(Egerton MS. 768)
Ninth century [p. 63]

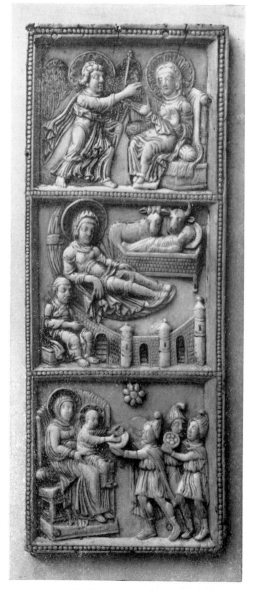

Plate 22. Leaf of an ivory diptych with scenes
from the childhood of Christ
Carolingian, ninth century [pp. 47, 50]

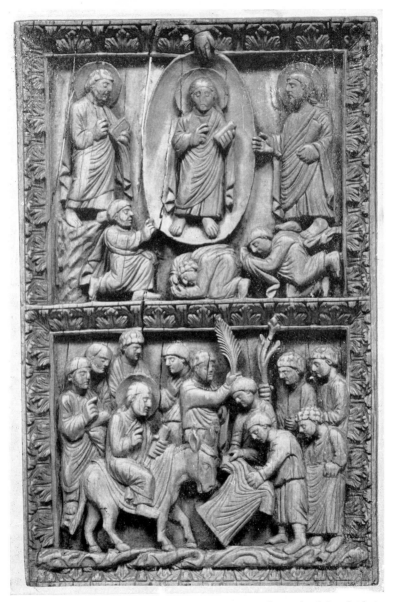

Plate 23. Leaf of an ivory diptych with scenes from the life of Christ
Carolingian, tenth century [p. 53]

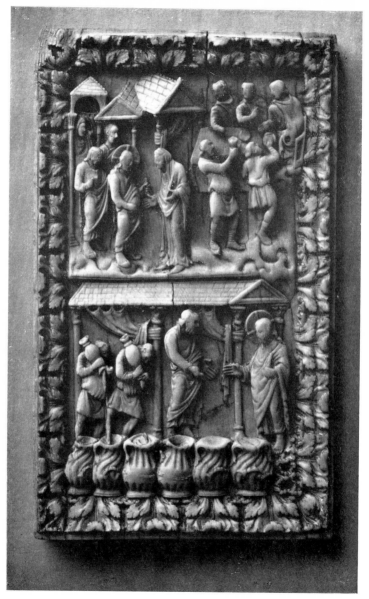

Plate 24. Ivory panel with the Miracle at Cana
Carolingian ninth century

[p. 44]

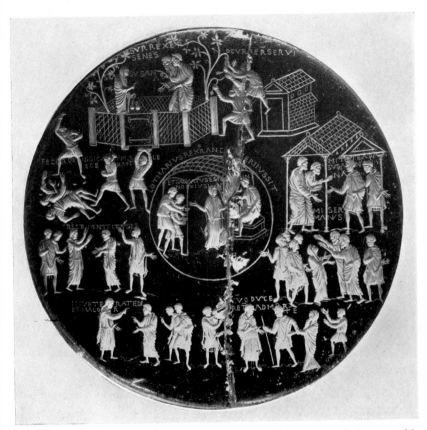

Plate 25. Rock-crystal engraved with the Story of Susanna and the two Elders
(The Crystal of Lothar)
Carolingian, ninth century

[pp. 41, 49]

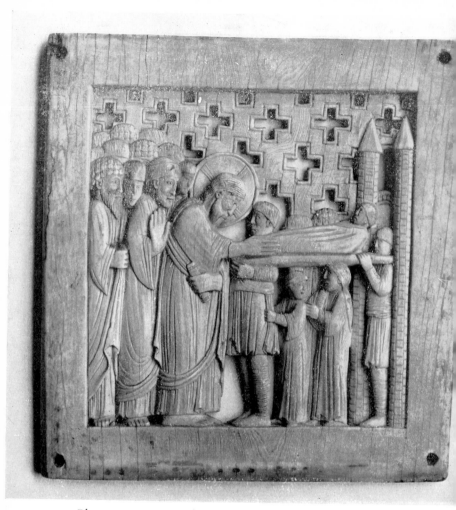

Plate 26. Ivory panel with the Raising of the Widow's Son
Ottonian, about A.D. 970

[p-

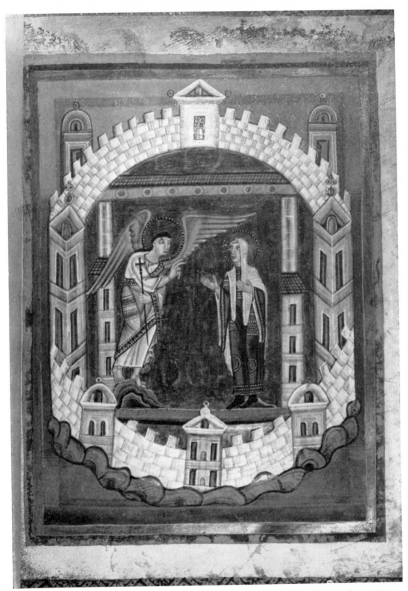

Plate 27. The Annunciation, from a German Gospel-book (Harley MS. 2821)
Ottonian, early eleventh century

[p. 71]

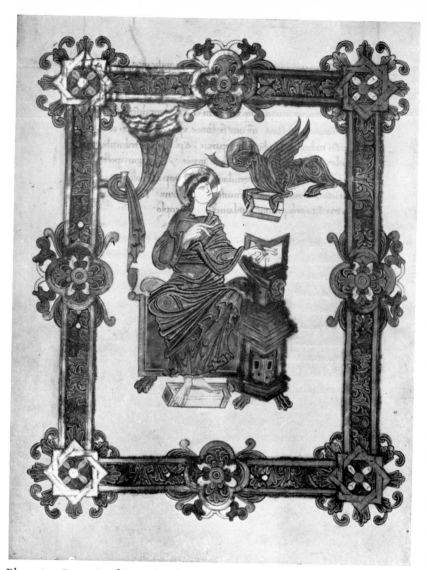

Plate 28. Portrait of St. Luke, from an English Gopel-book (Add. MS. 34890)
Early eleventh century

[p. 62]

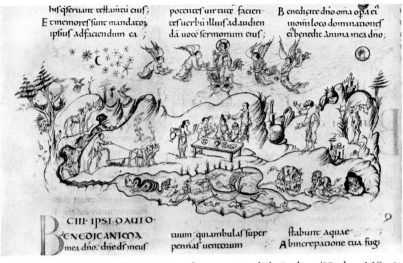

Plate 29A. Illustration of Psalm civ, from an English Psalter (Harley MS. 603)
About A.D. 1000 [p. 44]

Plate 29B. St. Pachomius receiving the Easter tables, from an English
manuscript (Cotton MS. Caligula A. XV)
Eleventh century [p. 65]

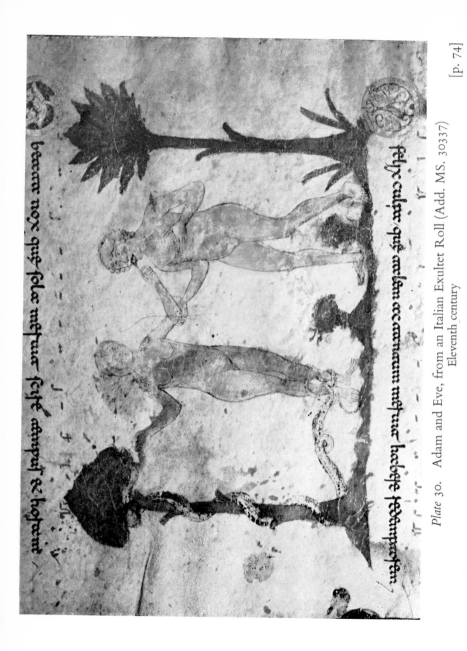

Plate 30. Adam and Eve, from an Italian Exultet Roll (Add. MS. 30337)
Eleventh century

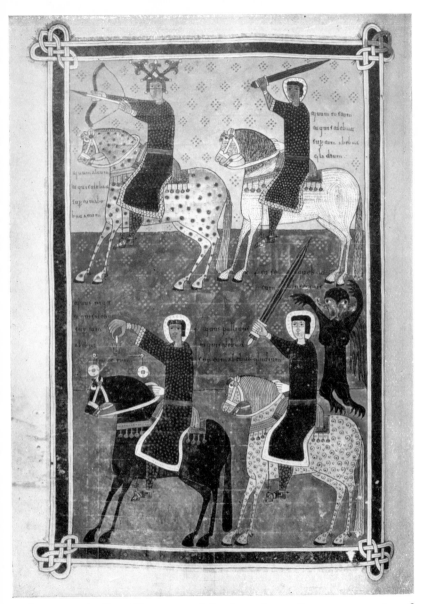

Plate 31. The Four Horsemen of the Apocalypse, from a manuscript of
Beatus' Commentary on the Apocalypse (Add. MS. 11695)
Spanish, about A.D. 1100 [p. 76]

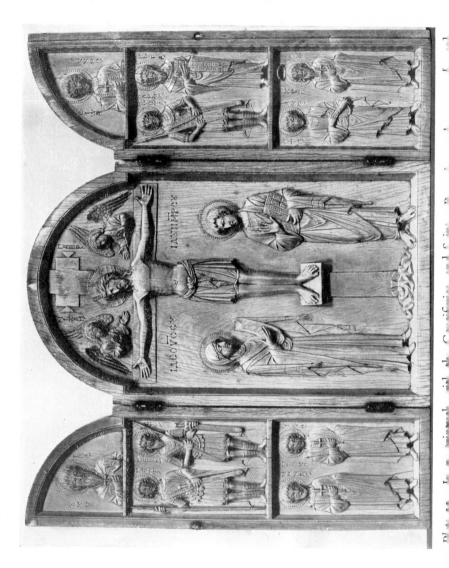

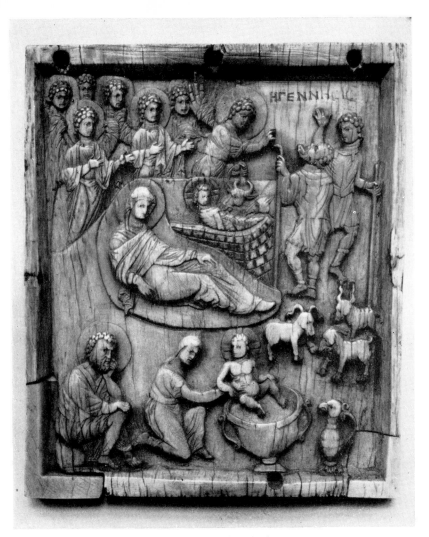

Plate 33. Ivory Panel with the Nativity
Byzantine, tenth century

[p. 56]

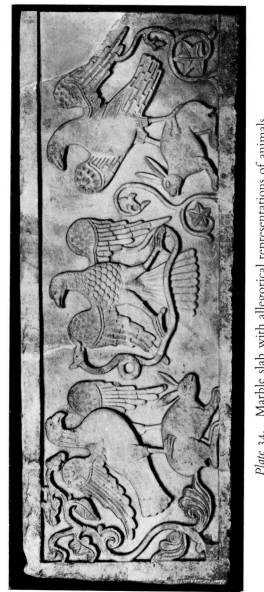

Plate 34.　Marble slab with allegorical representations of animals
Byzantine, tenth to eleventh century

Plate 35. The Manna and the Quails, from a Byzantine Psalter
(Add. MS. 40731)
Eleventh century

[p. 60]

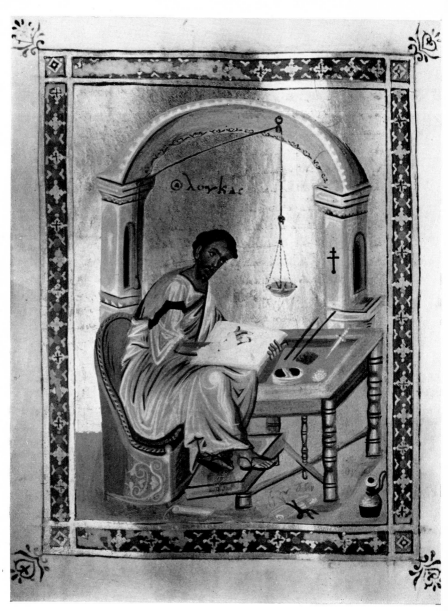

Plate 36. Portrait of St. Luke, from a Byzantine Gospel-book
(Add. MS. 28815)
Tenth century

[p. 59]

Plate 37. The Martyrdom of St. Anthimus, from a manuscript of
Simeon Metaphrastes' Lives of Saints (Add. MS. 11870)
Byzantine, eleventh to twelfth century [p. 94]

Plate 38. Enamelled cross with Old-Testament scenes, by Godefroid de Claire
Meuse region, twelfth century

[p. 86]

Plate 39. Bronze cover of a censer
Lower Rhine or Meuse (?), late twelfth century

[p. 87]

Plate 40. Stone capital with the Miraculous Draught of Fishes, from
Lewes Priory
English, twelfth century

[p. 85]

Plate 41A. Ivory chessmen from the Island of Lewis
Scandinavian or English, about A.D. 1200

[p. 83]

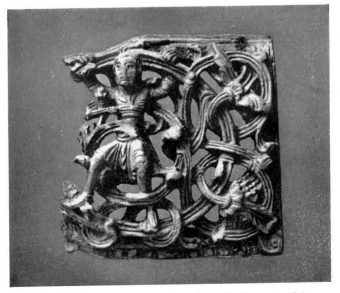

Plate 41B. Fragment of ivory panel with male figure in foliate scroll
English, twelfth century

[p. 93]

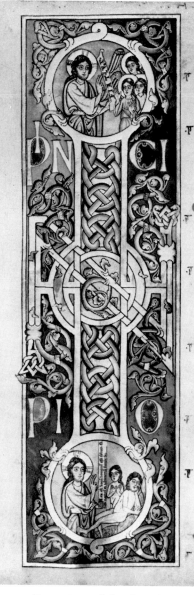

CREAUĪDS: CELV
et tram. Terra autē erat manis et uacua
et tenebre erant sup faciem abyssi. et spē di
strebat sup aquas. Dixit q̄ deus. fiat
lux et facta est lux. Et uidit deus lucē q̄d
esset bona. et diuisit lucem a tenebris. Ap
pellauitq̄ lucē diem. et tenebras noctem.
Factumq̄ est uespere et mane. dies unus.

Dixit quoq̄ deus. fiat firmamentum
in medio aquariū. et diuidat aquas
ab aquis. Et fecit deus firmamentū. diuisit
q̄ aquas que erant sub firmamento. ab hi
q̄ erant sup firmamentū. Et factū est ita.
Uocauitq̄ deus firmamentū celum. Et factū
est uespe et mane. dies secds.

Dixit uero deus. Congregentur aque que
sub celo sunt in locum unum. et ap
pareat arida. factumq̄ est ita. Et uocauit
deus aridam terram. congregationesq̄ aq
rum appellauit maria. Et uidit deus
quod esset bonum. et ait. Germinet ter
ra herbam uirentem. et facientem semen.
et lignum pomiferum faciens fructū
iuxta genus suum. cuius semen in se
metipso sit super terram. Et factū est
ita. Et protulit tra herbā uirentē. et affe
rentē semen iuxta genus sui. lignūq̄
faciens fructū. et habens unū quodq̄
semente secdm speciem sua. Et uidit deus
q̄d eet bonū. factūq̄ e uespe et mane. dies
tercius.

Dixit aute ds. fiant luminaria in fir
mamto celi. ut diuidant diē ac nocte. et sint
in signa et tempora. et dies et annos. ut
luceant in firmamto celi. et illuminent
tram. Et factū est ita. Fecitq̄ ds duo mag
na luminaria. luminare maius ut preet
diei. et luminare min' ut preet noch. et stellas
et posuit eas in firmamto celi. ut lucerēt sup
trā et preeet diei ac nocti. et diuideret luce a
tenebis. Et uidit ds q̄d eet bonū. et factū est
uespe et mane. dies quartus.

Dixit etiā ds. Producāt aq̄ reptilia anime

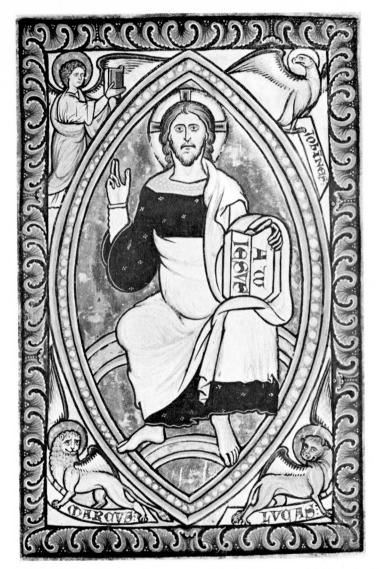

Plate 45. Christ in Majesty, from an English Psalter (Royal MS. 2 A. XXII)
About A.D. 1200

[p. 89]

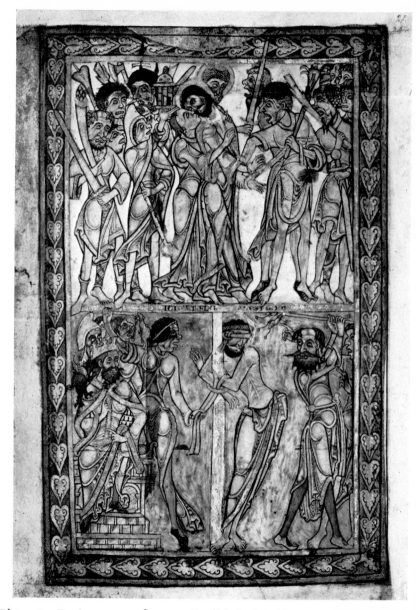

Plate 46. Passion scenes, from an English Psalter (Cotton MS. Nero C. IV)
Twelfth century [p. 93]

ſber.

Eſt animal quod dicitur ſber duo cornua habenſ. quarum tanta uiſ eſt uo ſi ab alio mortuſ ad ima demiſſuſ fuerit. corpuſ eiuſ totum biſ duobz cornibz ſuſtinetur illeſum. Significao autem erudtoſ homineſ. qui duorum teſtamentorum conſonantia quicquid eiſ aduerſi accidit quaſi quodam ſalubri tempamento tempare ſolet. & uelõ duobz cornibz ſub bona q ppetuo uereriſ teſtamentm ac euuͥglice lectioniſ atteſtatione ſuſtentant. yena.

Plate 47. Page from an English Bestiary (Harley MS. 4751)
Late twelfth century [p. 91]

Plate 48. St. Cuthbert on a sea voyage, from a Life of St. Cuthbert
(Add. MS. 39943)
English, early thirteenth century

[p. 97]